Tone and Color Correction

by
Gary G. Field

Graphic Arts Technical Foundation
4615 Forbes Avenue
Pittsburgh, Pennsylvania 15213
United States of America
Telephone: 412/621-6941
Telex: 9103509221 Fax: 412/621-3049

Contents

Preface

This text is intended for use as an instructional tool in the field of tone and color correction. The primary audience is those who are involved in the day-to-day task of making tone and color corrections, but it is anticipated that this book will prove to be of value to a secondary audience consisting of sales representatives, quality control specialists, production management, and buyers of printing. Apprenticeship training programs and students in some college courses could also make profitable use of this book.

The author has kept the overlap between this text and other GATF books on the subject of color to a minimum; consequently, the reader may have to refer to some of these other publications for supplemental information. An appendix is provided that not only lists appropriate GATF sources for further reading but also lists other publications that will prove to be of value.

Several authorities from industry and education have been kind enough to review selected chapters of this book: chapters 1–3 were reviewed by Professor Robert Chung of the Rochester Institute of Technology, chapter 4 by Charles E. Rinehart of Eastman Kodak Co., chapters 5–6 by Don Hutcheson of Crosfield Electronics, chapters 7–9 by Ian Haysom, now retired from the Melbourne College of Printing and Graphic Arts, chapter 10 by Anthony P. Stanton of the Graphic Arts Technical Foundation, and chapter 11 by George W. Leyda of 3M. The entire manuscript was also reviewed by Richard D. Warner and Frank V. Kanonik of the Graphic Arts Technical Foundation and Bruce Tory, graphic arts consultant, formerly of Leigh-Mardon Pty. Ltd. Many of the reviewers' suggestions were adopted for the final version, but any errors or omissions are the responsibility of the author.

At GATF, Thomas M. Destree edited the manuscript, Mary Alice O'Toole produced many of the illustrations, and Martin S. Gonzales was responsible for much of the photography. Several companies and individuals generously provided photographs and other materials to help illustrate the text. Their contributions are noted where they appear.

The author expresses his thanks to these persons and all others involved in the production of this text. He also extends his thanks to Harvey R. Levenson, head of the Graphic Communication Department at the California Polytechnic State University, for his encouragement and support.

Gary G. Field
San Luis Obispo, California
November 1990

1 Reasons for Tone and Color Correction

The word "correction" suggests that a conscious change or alteration must be made to the normal course of events so that the desired results may be achieved. When the term is used in connection with the color separation process, it means that the normal process of separating an original by separate exposures through red, green, and blue filters is insufficient to achieve high-quality color reproduction.

In a few rare cases, color separation without correction may be satisfactory. Such cases involve either low-contrast and low-saturation originals, or relatively modest quality expectations on the part of the customer. The assumption made in this text is that the highest possible quality is always the objective, and that the supplied originals and subsequent manufacturing conditions present the maximum degree of difficulty in achieving the quality objectives.

There are four general reasons why tone and color correction are necessary in the color separation process:
- Characteristics of the printing process, which include ink, paper, press, and plate properties
- Tonal and color properties of the original
- Characteristics of the color separation system, including filters, films, light sources, and scanner sensors
- The specifications of the customer

Although these reasons for correction are discussed under separate headings, it must be remembered that the actual process of correction is generally applied without any one specific correction reason in mind. That is, the objective is to produce color separation films containing values that, when printed, will produce the desired colors. To achieve the correct values on the films, *all* of the reasons for tone and color correction must be addressed.

Ink and Paper Characteristics

In general, the properties of the inks and the papers (or, more broadly, substrates) are the major reasons that tone and color correction procedures must be used when making color separations. In fact, the combined corrections dictated by *all* of the other factors are usually less than those required for the paper and ink factors.

Ink. The major process ink requirement regarding color properties is the selective absorption of light. Generally speaking, each of the three process color inks should absorb

one-third of the visible spectrum and transmit* the other two-thirds. Yellow inks should absorb blue light and transmit red and green; magenta inks should absorb green light and transmit red and blue; and cyan inks should absorb red light and transmit blue and green. The exact nature of inks having "ideal" absorption characteristics cannot be defined with certainty because there are several ways, at least in theory, of achieving the ideal.

Actual inks fall short of ideal, however "ideal" is defined. Yellows are fairly good, but magentas do not transmit enough blue light, and cyans do not transmit enough blue or green light. The lack of blue-light transmission from both magentas and cyans means that saturated blues, violets, and purples tend to reproduce poorly.

Black inks should absorb all light. In practice, most black inks tend to be slightly on the "warm" side, but this condition rarely creates serious problems.

Apart from correct absorption characteristics, the other major requirement for the yellow, magenta, and cyan inks is that they should be transparent. Unfortunately, yellow, magenta, and cyan process inks are not perfectly transparent. An ink lacks perfect transparency if, when it is printed over a solid black, the black takes on the hue of the ink. Imperfect transparency means that the color of the reproduction will depend somewhat on the sequence in which the inks are printed. The last ink down tends to determine the color cast of the reproduction.

Paper. The major paper factor that influences color reproduction is probably smoothness. Poor smoothness not only lowers resolution of the reproduction but also adversely influences tone reproduction. Coating type and coating weight contribute to smoothness and other substrate color reproduction quality factors. Rough papers generally require thicker ink films to produce even coverage. This, in turn, leads to higher dot gain than if a thin film was used.

Paper gloss is related to smoothness: the smoother the paper, the higher the gloss. Gloss, as well as paper

*Technically, process inks should not reflect light. Rather, they should transmit light, which, in turn, is reflected back through the ink film by the substrate.

Spectrophotometric curves of a set of hypothetically "ideal" inks (straight-sided version): yellow *(top),* magenta *(middle),* and cyan *(bottom)*

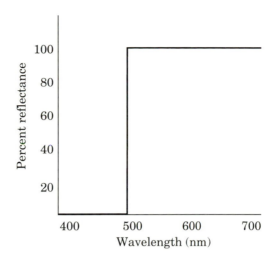

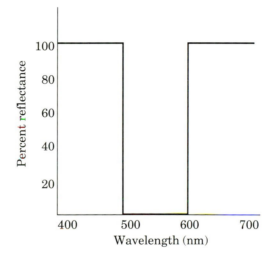

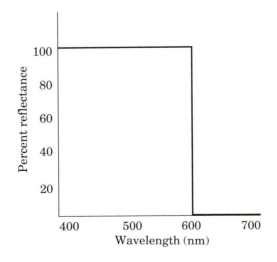

Spectrophotometric curves of a set of hypothetically "ideal" inks (slope-sided version): yellow *(top)*, magenta *(middle)*, and cyan *(bottom)*

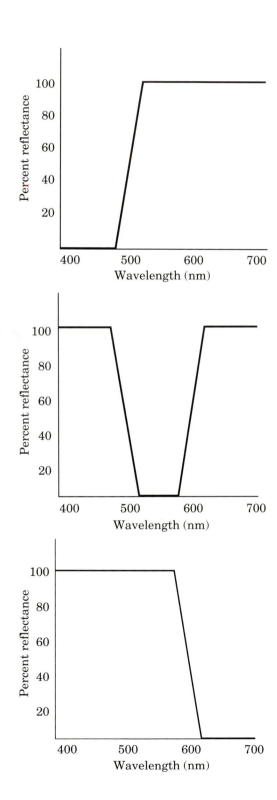

Spectrophotometric curves of a typical set of process inks: yellow *(top)*, magenta *(middle)*, and cyan *(bottom)*

The top curve in each illustration represents the spectrophotometric curve of the substrate.

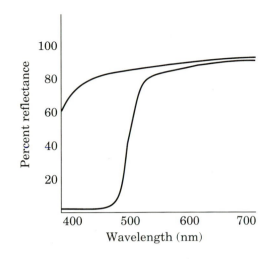

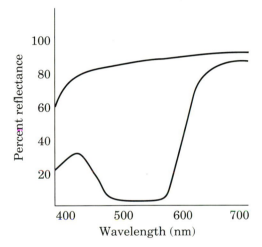

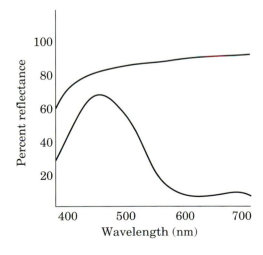

absorptivity, can seriously influence the color of a printed ink film.

Paper whiteness (neutrality) and brightness (how much light is reflected) are also important. Ideally, paper should reflect 100% of all wavelengths of light. In practice, paper rarely reflects any more than 90% of the light and tends to reflect more red and green light than blue light.

While the ideal whiteness and brightness properties of paper can be specified with some certainty, the same cannot be said for smoothness and gloss. If the original is a watercolor painting, the reproduction should be made on uncoated paper similar to that used for the painting. When reproducing a photograph, however, maximum gloss and smoothness are desired in order to best capture the qualities of the original.

The substrate should have high opacity in order to avoid show-through of the image printed on the reverse side.

Press-Related Factors

Ink film thickness, ink trapping, and dot gain are the major tone and color factors that may be influenced by press adjustments and settings. Other image quality factors such as register and moiré patterns may also be influenced by the press operator.

Ink film thickness. The primary method of controlling color reproduction on press is to vary the ink film thickness of each of the colors. As ink film thickness is increased, density and saturation tend to increase. At a certain point, however, the color of the ink tends to shift. Magenta inks, for example, become redder at higher ink film thicknesses and bluer at lower thicknesses.

Ink trapping. Trapping refers to how well one ink transfers to a previously printed ink. If, for example, a yellow ink does not transfer as well to a previously printed cyan ink as it does to unprinted paper, the hue of the yellow and cyan overprint will be bluish green. The trap of one ink over another is influenced by the thickness of the first-down ink, the thickness of the second-down ink, press speed, tack of the inks, and whether the first-down ink is wet or dry.

Dot gain. Increase in dot size from the plate to the printed sheet influences the tonal characteristics of the

Change in dot size from film to plate to blanket to paper in offset lithography
Courtesy Heidelberger Druckmaschinen AG

Two halftone dots on film (enlarged approximately 150 times)

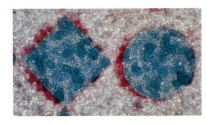

The same noninked halftone dots on the plate (plate has been washed; traces of magenta coating still visible)

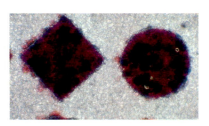

Halftone dots on the plate after inking

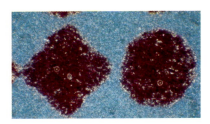

Halftone dots on the rubber blanket

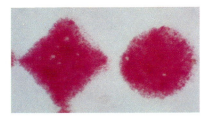

Printed halftone dots on paper

reproduction. A loss of detail in shadow tones and dark midtones are often the result of excessive dot gain on press. Dot gain is influenced by ink film thickness, impression cylinder pressure, the offset blanket, and other factors including the type of plate.

Some degree of dot gain is inescapable. To transfer ink to paper, pressure must be used. This pressure causes spreading of the image; however, this is not necessarily a problem. The key factor is that dot gain should be constant from day to day, rather than at some arbitrary level. Allowance for dot gain can be built into the color separations if gain is predictable.

Press control. Generally, the press operator adjusts the four ink film thicknesses (and the water feed in the case of lithography) to achieve the color saturation, trapping, and dot gain to suit the job at hand. If the prepress work has been done properly, many press settings should be nearly the same every time a given ink/paper/press combination is used.

Printing Process Characteristics

Each of the individual printing processes has certain characteristics that influence the quality of the reproduction. Most of these factors concern the tone reproduction characteristics of the reproduction.

Lithography. This process is capable of the highest resolution—screen rulings up to 300 lines/in. (about 120 lines/cm) may be used under ideal conditions for lithography. Indeed, screenless printing, which has even higher resolution, is possible for this process but, due to control difficulties, is not very common.

Some lithography lacks good color saturation. There are two possible reasons: too much water in the ink; or an ink film that is too thin due, in part, to the fact that the image is offset to a rubber blanket before being transferred to paper. On the other hand, offset lithography is very good for subtle light tones and vignettes, especially on rough papers.

Gravure. A major strength of the gravure process is its ability to achieve high color saturation, especially on lower-grade papers. For best results, however, smooth paper is required for gravure printing.

Moiré and trapping problems rarely occur with gravure, but the cell structure of the cylinder can influence image resolution. Economic factors tend to restrict the use of gravure to relatively long-run work.

Relief. The relief processes of letterpress and flexography have some of the same characteristics. Light tones and vignettes tend to be reproduced poorly by both processes. On the other hand, especially for letterpress, color saturation tends to be high in heavy tones.

Unless smooth paper is used, the resolution of relief processes tends to be poor. In letterpress newspaper work, for example, relatively coarse screen rulings (e.g., 65–85 lines/in., or 26–33 lines/cm) are used. Little process-color work is still printed by letterpress, but process-color flexography continues to grow because of steady improvements in plate technology, water-based inks, and printing machine precision.

Screen printing. The primary advantage of the screen printing process is its ability to achieve unsurpassed color strength and saturation. On the other hand, the mesh that supports the stencil tends to limit the resolution of the process and can contribute to moiré. Screen rulings of 133 lines/in. (52 lines/cm) can be used by the high-quality screen printers. The screen printing of process-color work tends to be restricted to short-run billboard, poster, and similar jobs. The use of screen printing for process-color work is increasing because of improved materials, equipment, and procedures.

Tonal Properties of the Original

Many originals cause problems in the reproduction process because they were not intended as originals for reproduction. For example, 35-mm color transparencies are designed for projection on a screen. These transparencies, however, are often submitted as originals for printed reproduction. One problem with 35-mm color transparencies is that their density range (the difference between the lightest and darkest areas of the transparency) usually exceeds the density range that can be achieved with ink on paper.

In cases where the density range of the original is less than the potential density range of the reproduction, it is possible to match the tones of the original in the

reproduction. Many artists' drawings and some photographic color prints fall into this category.

In the more common case where the density range of the original exceeds the density range of the reproduction, some tones must be sacrificed in the reproduction. Most color transparencies fall into this category.

Spectral Properties of the Original

The spectral properties of colors in the original become a matter of concern if they cannot be matched by the ink/paper/press combination. Another problem occurs if artwork prepared using fluorescent colors is printed using conventional rather than fluorescent inks.

Many color reproduction problems can be avoided if artists and designers avoid using nonreproducible colors when preparing artwork. This is a reasonable requirement as commercial artwork is prepared *specifically* for reproduction and it is in everyone's best interest that the final result looks good.

In cases where art is prepared as an end in itself, such as fine art intended for hanging in a gallery, some problems can result from nonreproducible colors. The same is true where actual merchandise samples such as fabrics or paint chips must be used as originals in the reproduction process.

The color gamut or range of most color prints is generally similar to the gamut that can be obtained under good printing conditions. Color transparencies, however, usually contain strongly saturated colors that exceed the range possible with the best four-color process printing.

The colors in originals that tend to be the most difficult to reproduce are the strong saturated colors and the clean, light colors, especially in the blue and red range. In some cases, customers will elect to incur the added expense of five- or six-color printing to achieve a more faithful reproduction, but these cases are rare and tend to be restricted to the fine art poster and similar markets.

Spectral Sensitivities of Color Separation Systems

The spectral sensitivity of a color separation system is different from that of the human eye. This fact means that two original colors that appear alike visually may record differently because of the way the color separation system "sees" the colors. This characteristic is not due to an error on the part of the scanner or camera operator but is just inherent to the system and is something that must be corrected at some stage of the prepress process.

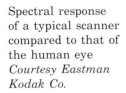

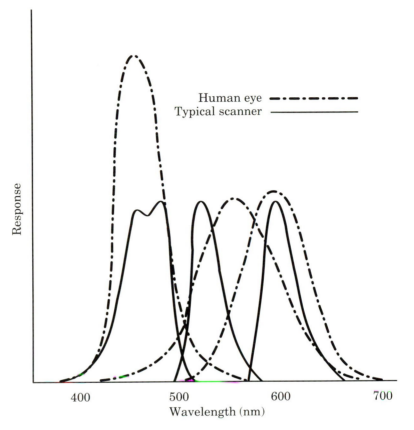

Color reproduction problems that are due to the spectral sensitivities of the color separation system can be minimized if the same type of color film is used for all originals and if a set of compatible pigments are used for hand-drawn artwork. Unfortunately, the color separator usually has little control over the kind of originals supplied for reproduction.

The spectral sensitivity problem is compounded by the fact that nonstandard light sources are used for color separation, whereas a standard 5,000 K light source is used for visual color evaluation. For a variety of reasons, this situation is not likely to change.

Color scanners. The factors that influence the spectral sensitivity of scanners are the light source; the absorption characteristics of the color separation filters; the absorption characteristics of the lenses, prisms, and other elements in the optical path; and the spectral sensitivity of the

photomultipliers. The spectral sensitivity of the recording film is irrelevant to the spectral sensitivity of the system since scanning the original and recording the image are separate optical operations.

Camera systems. Separations made using cameras, enlargers, or contact frames can be grouped in the camera systems category. The factors that influence the spectral sensitivity of these systems are the light source, the absorption characteristics of the color separation filters, the absorption characteristics of the lens and other optical elements, and the spectral sensitivity of the film being used.

Influence of ultraviolet radiation. Although ultraviolet (UV) radiation is invisible to the human eye, in some cases it will be "seen" by the color separation system. This radiation from some color separation light sources can also cause colors in the original to fluoresce and thus record differently from the visual appearance under standard illumination.

The UV radiation problem in cameras can be reduced by placing sheets of weatherable Mylar in front of pulsed-xenon lights. The sheets should be far enough away to allow satisfactory air circulation.

For scanners or contact light sources, a Wratten 2B filter placed between the light source and the original will be sufficient to absorb UV radiation. It is important to remember that UV radiation from the *light source* must be filtered in order to avoid fluorescence problems. Merely placing the UV-absorbing filter in the lens of a camera will *not* eliminate fluorescence.

Customer Specifications

Customer specifications that relate to tone and color correction are those supplied before the color separations are made or those marked on the color proofs. These specifications are used to indicate changes in color from those in either the original or proof.

Original specifications. In many cases, the original submitted for reproduction may not represent the ideal appearance desired by the customer. In catalog work, for example, the color of a fabric in the photograph may not match the actual fabric. Sometimes, the overall photograph

is poor, but it is the only one available. Under these and similar circumstances the customer will supply information to guide the color corrector to the desired color appearance.

The color information supplied by a customer should ideally be in the form of a physical color sample such as the actual merchandise or an area on a color chart. Words are generally too vague and ambiguous for color specification. Instrumental measurements may be of value, but few customers have the equipment or expertise to be able to supply information in this form.

Tonal adjustment can be clarified, to some extent, by the use of phrases such as "improve the highlight detail," "expand the shadows," or "flatten the harshness in the midtones." The color separator will get some idea of the *direction* of the change but will still not be sure of the *amount* of change that is desired. Generally, a proof must be made for the customer to be able to "fine-tune" tonal specifications.

Proof specifications. Ideally, all customer specifications should be supplied before the color separations are made. In practice, it is sometimes difficult to make color judgments until a proof of the finished job has been

Marking up a proof with color correction instructions

Note the use of a color chart and a standard color viewing booth.

produced. There are several reasons for this difficulty: the reproduction is a different size from the original; several originals may be combined into one page; and tints, logos, and other graphic elements may run around or through the reproduction. It is virtually impossible to preconceive the visual impact of this combination; hence the reason for customer-initiated changes after the proof has been made.

A proof that does not meet the original specifications closely enough is the other major reason for a customer to indicate changes on the proof. Color and tone changes should be indicated on a color chart that has been produced under similar conditions to the proof. Verbal descriptions of color adjustment, while in common use, are not particularly precise.

Tone and Color Correction Objective

The key objective in tone and color correction is to assess all of the factors discussed in this chapter and then to adjust the halftone or density values of the color separations so that, when printed, the desired reproduction will be produced. In this sense, the term "correction" may seem redundant—the objective is to simply achieve the right values in the separations. The phrase "tone and color adjustment" is really a better choice, especially with today's digital imaging systems, than "tone and color correction." The term "correction" has, however, been in use for many years of photomechanical processing and, like other terms, will probably survive the era of digital color imaging.

2 Color Reproduction Objectives

The objectives in color reproduction might be considered obvious: to satisfy the customer by producing a high-quality reproduction. Of course this is true, but this knowledge is not particularly helpful. What the color separator and corrector really need is information concerning how to please the customer within the manufacturing constraints of the processes that were discussed in Chapter 1.

The first and most important point to remember is that there is no unique procedure that always produces the desired reproduction from any original under any set of printing conditions. The role of the color separator and corrector is to customize the color separation films so that they incorporate the relevant information concerning both the original and the printing conditions. It might be thought that, if carried to an extreme, this approach would result in an infinite number of combinations and that every set of color separation films would be made differently from every other set. Fortunately, this is not the case. Broad classifications for both originals and printing conditions are established so that only a few color separation setups are necessary for the typical plant. Any "fine-tuning" of separations produced through one of the "basic" setups is accomplished on a job-by-job basis after assessing the proof. Such fine adjustments are achieved through the use of "local" correction, usually by the application of manual techniques.

Assessing the Original

The types of originals submitted for reproduction are discussed in Chapter 4. The objective now is to describe the factors concerning originals that influence the tone and color correction decisions.

Density range. The density range of the original can be measured with a densitometer. The densitometer is calibrated according to the manufacturer's instructions. The lightest and darkest points in the original are measured, and the difference between these values is the density range. Obtaining accurate density readings from 35-mm color transparencies may be impossible because the detail is so small relative to the diameter of the density probe. It is, however, rarely necessary to check the density range of 35-mm color transparencies because they are usually all around 3.00 or above. Indeed, most original

color transparencies regardless of their size have a range of around 3.0. Duplicate transparencies usually have a lower range.

The reason for measuring density range is to determine whether it exceeds the maximum range that can be achieved by the ink/paper/press combination in use. The printed density range is the density difference between the unprinted paper and the four-color solid (or the maximum density if a company has a policy of never printing four solids on top of each other).

If the density range of the original exceeds that of the printing conditions (this is usually the case), some or all of the tones in the original will be reproduced at a lighter density on the printed sheet.

Critical or "interest" areas. In general, some areas in the original are more critical than others to the reproduction. If originals contain mainly light tones, for example, the highlight region is the most critical area of the reproduction. The reproduction of shadow tones in this kind of original (called "high key") can generally be sacrificed in order to optimize the most important areas of the original. In those cases where the original consists mainly of dark tones ("low-key" originals), the shadow region is more important than the highlight region.

Product colors, especially for catalog printing, are generally considered critical areas. Memory colors (that is, those colors such as grass, sky, and skin) are also important areas. It is reasonable to assume that colors not related to the product being displayed or those where no color memory exists on the part of the observer are of lesser importance. This is especially true if the color area in question is small relative to the size of the critical color areas.

In many cases, the critical tones or colors in an original are not obvious to the color separator or corrector. The printing sales representative should find out from the customer what areas are most critical to the reproduction. It is a given fact in most reproductions that tone and color distortions are unavoidable. The exact nature of the distortion *is* adjustable; and if the desires of the customer are known, the distortion can be one that produces the best quality reproduction.

Estimated tone reproduction curves for transparency reproduction, showing interest area emphasis for high-key *(top),* normal *(middle),* and low-key *(bottom)* photographs

The highlight density point of zero-useful detail is taken as 0.30 in correctly exposed transparency originals. An estimated curve for low-key originals (not part of the original research) is also presented.

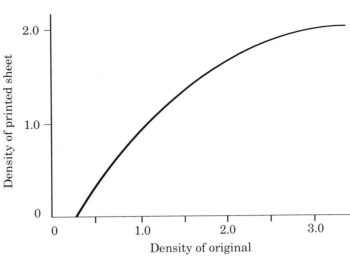

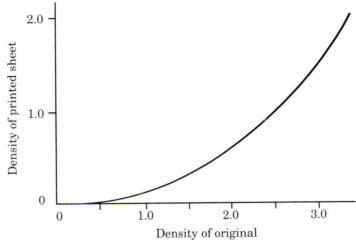

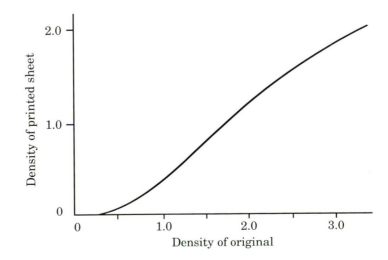

The color separator and corrector should identify nonreproducible colors and tones before making the color separations. This information should be conveyed to the sales representative, who can inform the customer. The objective here is to identify potential problems before the fact rather than to try and explain the proof after the fact.

Reproduction scale. The size of the reproduction relative to the size of the original also influences the tone correction decisions. If no adjustments are made for the reproduction size, great enlargements appear to have lighter middletones than desired and great reductions tend to have darker middletones than desired. Generally speaking, reproduction scales in the range from 90% to 500% do not require any tone adjustments specific to scale.

Middletone corrections for various reproduction percentages

Reproduction Percentage	Midtone Dot Change
20	Reduce by 15%
40	Reduce by 10%
60	Reduce by 5%
80	Reduce by 3%
100	No change
600	Increase by 5%
1000	Increase by 7%
1500	Increase by 9%
2000	Increase by 10%

Other factors. The color separator should carefully inspect the originals for signs of scratches, dirt, fingerprints, or other damage. In serious cases, these defects should be reported to the sales representative before work is commenced.

Such details as the texture of an oil painting, evidence of retouching, poor focus, and graininess should be checked and recorded. It is important for the color separator and corrector to know whether the cost of correcting those defects that are correctable is included in the estimate, or whether the job should be treated "as is."

If potential problems of the originals are identified before the job is separated, there might be time to supply a new original in some cases. At the very least, the customer has been informed of potential problems at an early stage.

Evaluating the Printing Conditions

The printing conditions is the other major factor, apart from the original, that influences the tone and color adjustments. The term "printing conditions" can be defined

to include all of those stages that follow the production of the corrected films. These stages would include contacting, platemaking, printing (ink/paper/press), and such finishing operations as varnishing.

Contacting and platemaking. The key information required at this stage is whether negative or positive films are needed. If negative films are used to make the plate, a 2–4% dot gain can be expected at the 50% level. If positive films are used, a 1–3% dot loss will occur. Positive tonal values, at the 50% step on the plate, should therefore be about 5% heavier than the same step on negative films.

Different kinds of negative and positive plates, as well as different plate exposure frames and light sources, could cause differing amounts of gain. The same could be said for film contacting conditions; therefore, each plant should characterize its own conditions through a series of controlled tests using appropriate test images.

Printing and finishing. The press, paper, and ink used to print the separations have a major influence on the appearance of the final reproduction. The interaction of these variables influences the dot gain, trapping, and colorimetric properties of the printed ink films.

Paper smoothness, impression pressure, blanket type (for offset printing), and ink film thickness influence dot gain. In the absence of a printed test chart that characterizes printing performance, the best that the color separator can do is to inquire whether the job will be printed on coated or uncoated paper.

Dot gain on uncoated paper will be 5–10% higher than on coated paper. That is, a 50% dot on coated paper will reproduce between 55–60% on uncoated paper.

Ink trap influences the appearance of the overprint colors—red, green, and blue. A variety of ink, paper, and press factors influence trapping, but it is impossible to predict their effect on appearance without a printed test chart.

The colorimetric properties of the printed ink films are influenced by the paper and the ink pigments. Papers that have a combination of low gloss and high absorbency tend to degrade the color of the printed ink film more than high-gloss and low-absorbency substrates. The major

The UGRA Plate Control Wedge (shown enlarged)

The UGRA Plate Control Wedge, available from GATF, is designed to control the lithographic platemaking process (both positive and negative). It consists of a line film into which a continuous-tone film has been stripped.

In platemaking and film contacting, the wedge enables exposure, exposure latitude, resolution, gradation, and rendering of halftone dots to be evaluated. In proofing and printing, slur, doubling, and tone reproduction can be evaluated.

The UGRA Plate Control Wedge consists of five elements:

- Calibrated continuous-tone wedge (13 steps at 0.15 density increments)
- Microline resolution target (12 circular patches with positive/negative halves)
- 150-line/in. (60-line/cm) calibrated halftone wedges
- Doubling/slur targets
- Positive/negative highlight and shadow dot control patches

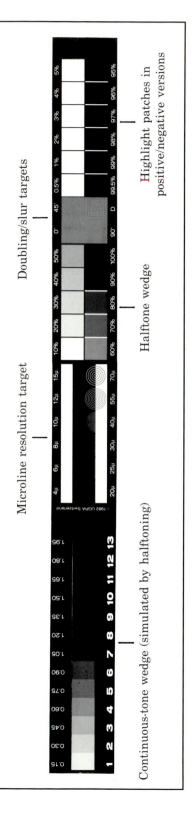

Microline resolution target

Doubling/slur targets

Halftone wedge

Highlight patches in positive/negative versions

Continuous-tone wedge (simulated by halftoning)

differences in ink pigments seems to be centered on magenta inks. Magenta pigments range from blue-shade to red-shade. The gray balance requirements of the separations are influenced by the choice of magenta pigment.

Again, in the absence of a printed test chart, the color separator should ask whether a red- or blue-shade magenta is being used. In order to achieve gray balance (i.e., neutral grays made of yellow, magenta, and cyan; sometimes called color balance) when blue-shade magentas are used, the yellow dot should be about 4–5% higher than the magenta dot in the middletones and correspondingly higher elsewhere in the tone scale.

The other printing factors that influence how the separations are made concern paper smoothness. Smoother papers mean that finer screen rulings may be used which, in turn, increases the resolution of the reproduction. A further quality of high-smoothness papers, especially if they are glossy, is that first-surface reflections are minimized, thus increasing the apparent contrast of the reproduction and saturation of the printed colors. Varnish is sometimes applied to the print in order to enhance this effect. Under such circumstances, the color separator makes fewer allowances for tone scale compression.

In summarizing the influence of the printing conditions on the reproduction, the paper characteristics are potentially the most important single factor. Specifically, the color separator should determine whether coated (smooth) or uncoated (rough) paper will be used to print the job. Ideally, of course, a printed test chart, generated under the actual manufacturing conditions, should be made available to the color separator and corrector. The generation and use of such charts is described in chapter 3.

Tone and Color Objectives

It might be thought that the objective in color reproduction is to simply match the original. In some cases, it is undesirable to do this; in other, more frequent cases, it is impossible to do this. Actually, there are three possible sets of conditions that dictate the approach taken to tone and color correction:

- Color match is desirable and achievable.
- Color match is achievable but not desirable.
- Color match is desirable but not achievable.

Color match is desirable and achievable. In this case, the customer has furnished an original that does not exceed the tone and color range achievable by the printing conditions. These circumstances are relatively uncommon.

The kind of original that does not exceed the density range of the printing process is usually a reflection photograph or an artist's drawing. Some oil paintings and some high-gloss photographs, however, exceed the range offered by most printing conditions.

The printing conditions most likely to exceed the density range and color gamut of most reflection originals are those where a smooth, white, bright coated paper is used. A blue-shade magenta ink extends the gamut in blue and purple areas, and fifth or sixth colors extend the gamut even further.

Color match is achievable but not desirable. In a number of cases, it is technically possible to match the original but is not desirable to do so. For postcard or calendar work, it is often desirable to make skies bluer and grass greener than the supplied transparency in order to brighten the appearance of the reproduction. Likewise, skin tones are often adjusted to appear more natural or pleasing in the reproduction. Such adjustments are common when originals with objectionable color casts are supplied for reproduction. Over- and underexposed photographic originals are also adjusted in the reproduction process to make them appear more pleasing on the final print.

The other common case where a deviation from the original color is desired is catalog printing. The original photograph supplied for product advertising purposes may be satisfactory in all respects except that the color of the product in the photograph may be slightly inaccurate. In these cases, it is not unusual for the customer to submit a sample of the product color; e.g., a fabric sample or paint swatch. The color separator and corrector then separate the original photograph but use local correction techniques to adjust the product color to match the sample.

Color match is desirable but not achievable. The circumstances where it is desirable but not possible to reproduce a color are those that cause the most problems for the color corrector. The key concern in such cases is how to make the reproduction so that it is satisfactory.

Examples of differences in tone reproduction

The same original has been color-separated to emphasize middletones *(top)*, highlights *(middle)*, and shadows *(bottom)*

This problem can be addressed from the tone reproduction and color gamut viewpoints.

The main problem in regard to tone reproduction is that the density range of the original exceeds that available from the printing conditions. The most satisfactory solution is to compress the original in such a way that the "interest area" has less compression than the rest of the tonal areas. In the cases of a high-key original, for example, the highlight-to-middletone range should only have mild compression by comparison to the middletone-to-shadow range, which may receive greater compression because that particular original contains no important shadow detail. The reverse would be true for low-key originals, while a normal original would receive the least compression in the middletones and the most in the extreme highlight and extreme shadow areas. The adjustments are normally made during the color separation stage.

In many cases, customers find it difficult to express their tone reproduction preferences. Sales representatives should carry sample reproductions with a variety of tone curves. The subjects in these reproductions should include normal, high-key, and low-key originals. Customers choose the reproduction that most closely captures the "feel" they are trying to convey.

Tone reproduction adjustments as described in the previous paragraphs satisfy the lightness and darkness aspects of color. The hue of any color may be matched exactly by varying the combination of yellow, magenta, and cyan inks that go into reproducing that color. The third and final dimension of color, saturation, is the one where color matching problems are most likely to be encountered.

In practice, especially for transparencies, the saturation of some original colors exceeds that available from the printing conditions. The two ways of dealing with this problem is to either degrade all colors in the original equally or to reproduce some colors with accurate saturation and to let the others fall where they may. This latter approach distorts the balance between color areas in the reproduction.

The best way to handle saturation compression is not known, but most research literature suggests that all colors should be degraded by the same amount. Sometimes, saturation compression needs can be established only after

Examples of
normal correction
(top), under-
correction *(middle)*,
and overcorrection
(bottom) of color

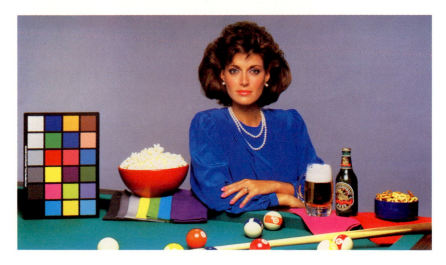

the proof has been made. The customer may direct that hue shifts be introduced in order to preserve the apparent color balance. The amount of color adjustment needed depends on the magnitude of color difference between the original and the reproduction, the relative size and shape of the colors that have been correctly reproduced and those that have been distorted, and their position relative to each other. In other words, it is sometimes impossible to predict the required color adjustments until a proof has been made.

The ideal way to handle the corrections for saturation is through the use of an accurate video proofing system. In this way, the color corrector is able to make reasonable adjustments prior to incurring the expense of making the separations and proofs.

Image Structure Quality Objectives

While the main thrust of this book is tone and color correction, it is also important to consider the quality of the image structure. It is possible to have precise tone and color, but a poor reproduction because of poor image quality. Several factors contribute to image structure quality, or the lack of it, namely resolution, sharpness, graininess, and moiré.

Resolution. Ideally, resolution should be as high as possible. This state is achieved by using the finest screen ruling allowable by the printing conditions. Other factors

Examples of high- and low-resolution reproductions

The high-resolution reproduction *(left)* was created using a 150-line/in. screen, and the low-resolution reproduction *(right)* was created using a 65-line/in. screen.

that influence resolution include the camera lens, the resolution of the separation films, and (on scanners) the electronic dot-generating techniques. In general, these conditions are not adjustable (except screen ruling) by the color separator, but whenever new equipment is purchased, a comparison should be made to determine which produces the highest resolution.

Sharpness. Sharpness may be enhanced by increasing the contrast in the narrow area of transition between light and dark areas in the original. This enhancement may be achieved either through the use of photographic masking techniques or appropriate scanner adjustments.

The optimal degree of sharpness for any given reproduction is not known with any certainty. Soft-focus portraits or landscapes would not be improved by enhancing the sharpness. Photographs of natural scenes or objects must not look artificial. On the other hand, man-made objects such as machinery, jewelry, or fabrics may benefit from the use of sharpness enhancement techniques. If, however, a "gritty" or "grainy" appearance is noticeable in the reproduction, too much sharpening effect has probably been used.

Reproductions having normal sharpness *(left)* and enhanced sharpness *(right)*

Graininess. One objective in color reproduction is to not add to the graininess inherent in the original through the use of inappropriate techniques. If indirect camera separation techniques are used, it is important that the continuous-tone separation films are not enlarged to the point that their grain is visible in the reproduction. When scanners are used for color separation, the sharpness

A 35-mm
transparency
reproduced at
800%, showing
excessive
graininess

controls should not be set to the point where the grain in
the original is accentuated.

Graininess problems may be minimized by asking for
large originals that are close to the size required for the
final reproduction. If 35-mm film must be used for the
original photographic work, Kodachrome offers the finest
grain.

Moiré. In any halftone printing process, some moiré (or
screen pattern), is always present. When fine screen
rulings and proper angles are used, moiré is almost
invisible. Incorrect screen angles, a worn printing press, or
an improperly setup press may cause moiré in the
reproduction. Even in cases where everything has been
done correctly, this problem may arise.

Moiré in certain colors may be minimized by switching
certain screen angles. Exchanging the magenta and black
angles, for example, minimizes patterns in browns and skin
tones.

In the case of electronically generated dots, the angles
are preset by the manufacturer to suit the dot generation

technique. Test films should be obtained from a sampling of scanners to determine which are less likely to give moiré problems under a given plant's printing conditions.

Sometimes a moiré pattern will be created between the halftone screens and a pattern in the original (usually a fabric texture or pattern). In such cases, angle the copy about 30° away from normal and reseparate the job. Keep adjusting the angle by trial and error until the pattern disappears. In some cases, however, it is virtually impossible to avoid a moiré pattern between the halftone screens and detail in the original.

3 Characterizing the Printing System

The previous chapter stressed the influence that the printing conditions can have on the appearance of the final reproduction. The color separator and corrector need to have tangible evidence in the form of a test chart of the printing conditions in order to consistently produce high-quality color separations.

In some cases, the printing conditions will remain unknown to the color separator and corrector. Such occasions arise when customers purchase color separations and color printing as two separate and unrelated activities, a practice bound to cause erratic color reproduction quality. In the absence of supplied printing specifications, the color separator should produce separations to an internal plant standard. This internal standard may be based on one of the more common off-press color proofing systems, or if press proofs are made in the plant, the standard inks, paper, and press setup should be selected to approximate the average printing performance of the plant's printer customers.

Stabilizing the Printing Process

The test charts supplied to the color separator and corrector should be truly representative of the printing conditions at hand. If they are not, the time and effort taken for careful calibration of the separation equipment will be wasted and the plant will be no better off than if trial-and-error methods were used.

The ideal conditions for printing a test chart are those that are most commonly used for production work. In other words, the press crew should not strive to produce the best possible printing of a test chart if those conditions are not representative of actual production conditions. Most plants will have to generate test charts for both coated and uncoated substrates. Large plants having web and sheetfed equipment, or those plants that use a variety of ink sets, may have to generate additional printed charts.

The easiest way to ensure that printed test charts are representative of normal printing conditions is to analyze samples of jobs printed in the previous six months or so. Ideally, the printed sheets should include a GATF Compact Color Test Strip or similar means of characterizing the printing conditions. The solid ink densities, percent trapping, and dot area can be measured with densitometers. These values may be averaged for both the coated paper samples and the uncoated paper samples in

Press operator
inspecting a
printed sheet that
includes a GATF
Compact Color Test
Strip

A test strip or
similar image
should be included
in all test forms.

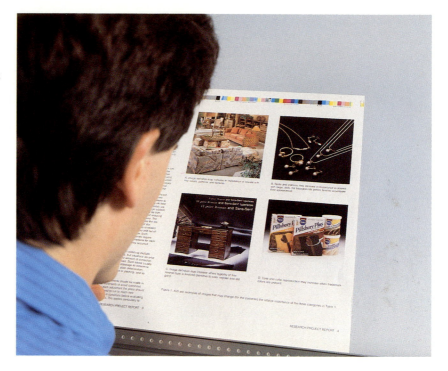

order to establish targets for the test chart printing
conditions. The charts may be printed as a separate
pressrun or alongside a current job. Allowances for density
dryback must be made when printing the test charts.

Some information concerning the printing conditions
cannot be determined from an analysis of the printed color
bar. Such information as ink color sequence, press speed,
ink and paper manufacturer and type, or special conditions
that require a deviation from normal procedures should be
recorded in a production log. Such information is used
along with the data collected from the color bar analysis to
help establish the typical printing conditions required for
test chart production.

**Gray Balance
Chart**

The most useful chart for establishing color separation film
requirements is a gray balance chart. The GATF chart, for
example, can be used to characterize dot gain, establish
color balance, and partially determine color correction
requirements.

The primary purpose of a gray balance chart is to
establish the correct color balance between the yellow,
magenta, and cyan separations. This objective is achieved

GATF Gray
Balance Chart

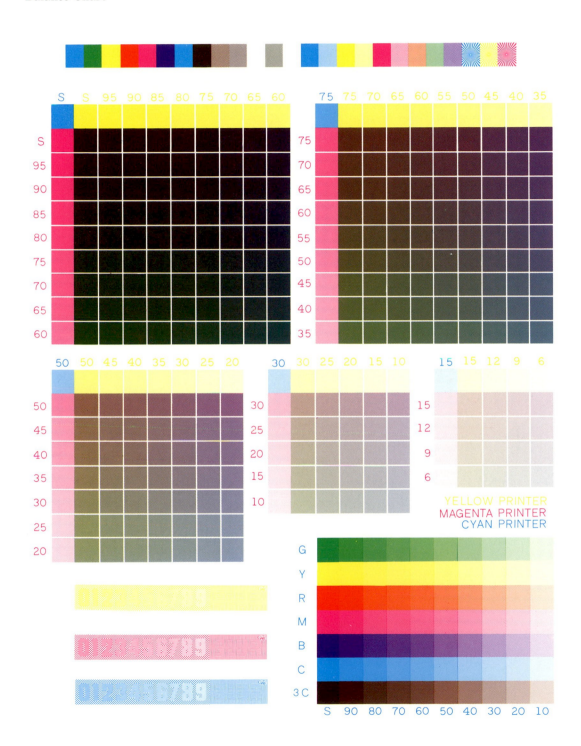

by determining the proportions of yellow, magenta, and cyan needed to produce a visually neutral gray.

The neutral grays in a gray balance chart are selected by using a neutral gray scale as a reference. The reference gray scale should have holes punched through each step of the scale to allow direct comparison with the reference areas on the gray balance chart. It is important that the grays be selected under the graphic arts industry standard 5000 K illumination.

The GATF Gray Balance Chart being analyzed to locate neutral grays

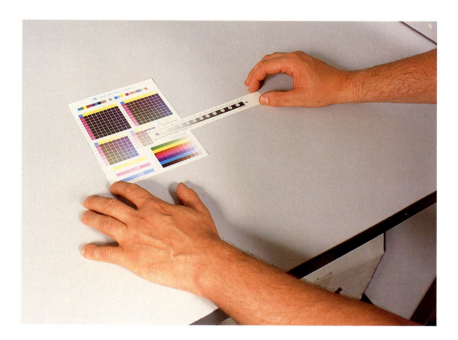

Selecting a neutral gray scale for comparison purposes requires some care. If, for example, the gray balance chart is printed on newsprint, the substrate color is usually far from neutral. Under such circumstances it is advisable to use a gray scale printed with black ink on the paper in question as the reference gray. The human eye adapts readily to different color substrates; thus, the eye will take the black-and-white pictures in a newspaper (for example) as a reference neutral scale. It is important, therefore, that the color balance is established by reference to the same scale. The GATF Halftone Gray Wedge is a useful device for generating a neutral gray scale for any given set of conditions. Holes are punched in the printed gray wedge at the points that most closely correspond to the three-color gray areas in the printed gray balance chart.

GATF Color Reproduction Guide *(top)* and GATF Halftone Gray Wedge *(bottom)*

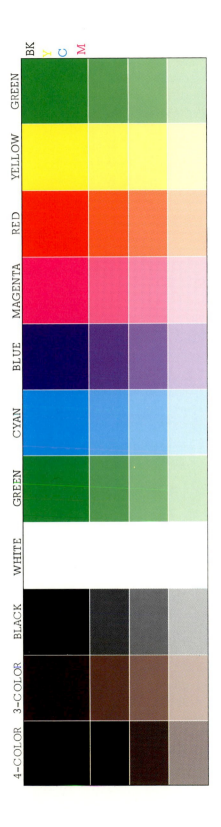

133 *line/inch*

Graphic Arts Technical Foundation; Pittsburgh, Pennsylvania 15213

Several people should analyze the printed gray balance chart to determine the neutral areas. Some inter-observer variability is likely; therefore, the average of all observations should be used as the plant standard.

Color judgments must be made only by observers with normal color vision. Given that about 8% of the male population have abnormal color vision, appropriate tests should be used to make sure that those involved in making critical color judgments do have normal color vision. Color vision also changes as we age (the lens of the eye becomes yellower); consequently, a wide age range of observers should be used when averaged judgments are used.

Color Reproduction Guide

A miniature version of the GATF Color Reproduction Guide is included as part of the gray balance chart. In practice, however, the full-size version may prove much more convenient to use. A color reproduction guide, a gray balance chart, and other feedback test images may all be printed from the same test plates rather than as separate runs.

The color reproduction guide is intended primarily as a guide for color correction adjustment. Specifically, this guide helps to determine whether the color correction designed to compensate for the ink pigment deficiencies is satisfactory. The guide is mounted alongside reflection artwork when making camera separations, or wrapped around a scanner drum when adjusting the color correction controls.

In chapter 1, it was pointed out that there are other reasons for color correction than compensation for the unwanted absorptions of the ink pigments. Perfect correction as indicated by the guide, therefore, does not necessarily mean that correction for the live job is perfect.

The color reproduction guide consists of white and black (or three-color) areas that should reproduce the same on all separation films, and six separate color areas that reproduce differently on each separation. The six colors are the printing ink primaries (yellow, magenta, and cyan) and their two-color overlaps (red, green, and blue). On the yellow separation, the yellow, red, and green patches should record the same as the black patch, and the blue, cyan, and magenta patches should record the same as the white patch. For the magenta separation, the magenta, blue, and red patches should record the same as the black

patch, and the yellow, cyan, and green patches should record the same as the white patch. On the cyan separation, the cyan, blue, and green patches should record the same as the black patch, and the yellow, red, and magenta patches should record the same as the white patch. Finally, on the black separation, all six color patches should record the same as the white patch.

Other Charts and Guides

The color chart, such as the GATF Munsell-Foss Color Chart, is the best known of the other charts that provide the color separator and corrector with information concerning the printing conditions. The color chart, by providing a display of several thousand colors that have been produced by combining various percentages of yellow, magenta, cyan, and black, represents an invaluable tool for making precise color adjustments.

Color charts certainly require special pressruns for their production, hence making them fairly expensive. An alternative is to use one of the preprinted "off-the-shelf" color charts or guides. The danger with the latter approach

A preprinted color chart being used to locate a specific color

is that the conditions used to print the guide may be dissimilar to a given plant's production conditions, thus limiting the value of the guide or chart.

The advantage to generating color charts in-house is that the colors in the chart are truly representative of plant conditions. Some plants will produce a large quantity of charts so that an ample number are available for

production workers, sales personnel, and customers. Such color charts should be reprinted about once a year because printed charts can fade or deteriorate in other ways.

The other major type of test image designed to feed back information from the printing stage to the color separation stage is the GATF Halftone Gray Wedge, a continuously variable halftone scale. This image allows the color separator to more precisely compute dot gain than is possible through the use of the gray balance chart. The image is also used to determine the finest highlight and shadow dots that are reproducible by a given plate/ink/paper/press combination. Once these limits are determined from a test run, they become house standards for the maximum and minimum halftone dot values of color separation.

The Jones Diagram

The Jones Diagram, named after its inventor, Lloyd Jones, is an analytical device that allows the color separator to calculate how to make color separations that incorporate both the tonal distortions introduced by the printing conditions and the tone reproduction requirements of the original. In practice, this type of analysis is typically conducted in conjunction with a gray balance analysis.

The top right quadrant of the Jones diagram typically displays the desired tonal relationship between the original

The Jones Diagram, a device for analyzing the tonal relationship between the original, press sheet, and separation films

and the reproduction. The vertical axis displays the densities of the reproduction, while the horizontal axis displays the corresponding densities of the original.

The top left quadrant of the Jones diagram displays the relationship between the halftone values of the color separations and the corresponding three-color densities of the printed press sheets. Press sheet densities are plotted on the vertical axis, while percentage dot values are plotted on the horizontal axis. This quadrant contains the gray balance test data—that is, what yellow, magenta, and cyan dot values are required to achieve neutral three-color grays of a given density.

The bottom left quadrant of the Jones diagram is sometimes used to characterize the screening process when indirect color separation is used. This quadrant can also be used to show tonal distortion in the contacting process, but it is more common to use this quadrant as a transfer quadrant. A 45° line runs from the upper right to the lower left of this quadrant. Both the vertical and horizontal axes are halftone dot percentage scales. The 45° line merely transfers the readings from the horizontal axis to the vertical axis.

The bottom right quadrant of the Jones diagram is where the characteristics of the separation negatives are plotted. The plotting process starts with the upper right quadrant. A series of points, representative of the tone scale, are selected on the curve in this quadrant. Horizontal lines are drawn from these points into the top left quadrant until they cross the gray balance curves. Vertical lines are then extended from the intersected points on the gray balance curves to the 45° line in the bottom left quadrant. Horizontal lines are extended from these intersections into the bottom right quadrant. Finally, vertical lines are extended downward from the original points in the upper right quadrant into the lower right quadrant until they intersect their corresponding horizontal lines that had been previously extended into that quadrant. A smooth curve is drawn through the intersecting points for each color separation. The resulting curves are the ideal gradation curves for the color separation films.

The GATF Color Triangle

The best aid for determining whether a color in the original is reproducible on press is a color chart that has been produced under actual manufacturing conditions. In

the absence of such a chart, the GATF Color Triangle may
be used to show whether a color in a reflection original is
reproducible. The accuracy of this method, however, is only
approximate because it is based on densitometer measure-
ments rather than those obtained from spectrophotometers
or colorimeters.

First, the red-, green-, and blue-filter channels of the
densitometer (often indicated by cyan, magenta, and
yellow, respectively) are calibrated to zero on the unprinted
substrate. Next, each of the solid cyan, magenta, and
yellow patches are read through the red, green, and blue
filters. The three numbers that represent each ink color
are converted into two via the following equations:

$$\text{Gray \%} = \frac{L}{H} \times 100$$

$$\text{Hue \%} = \frac{M - L}{H - L} \times 100$$

where, H = the highest reading of that ink, M = the
middle reading, and L = the lowest reading. After the hue
and gray values for each color have been determined, they
are plotted on the GATF Color Triangle. The gray values
increase from the outer boundary to the center of the
triangle. The hue dimension is plotted around the triangle.
The final point in the characterization of the ink/paper
combination is to connect the three points that represent
the yellow, magenta, and cyan inks. The subsequent
triangle represents the saturation component of the gamut
obtainable by that ink/paper combination.

A color in a reflection original may now be measured
through the red, green, and blue filters of the densi-
tometer, converted to hue and gray parameters, and plotted
on the triangle. If the plotted color falls within the color
gamut triangle of the ink set, the hue and saturation of
this color can be matched by the ink set. If the color falls
outside the gamut triangle, it is not reproducible.

The third dimension of color not shown on the triangle is
called lightness, or density. The highest density reading
through the three filters for a given color can be used as a
rough measure of lightness. The highest density of a color
in the original could be compared with the corresponding
reading of the three inks to see if the density is within the
available range. These measures, however, are only
approximate because of the lack of corresponding data for

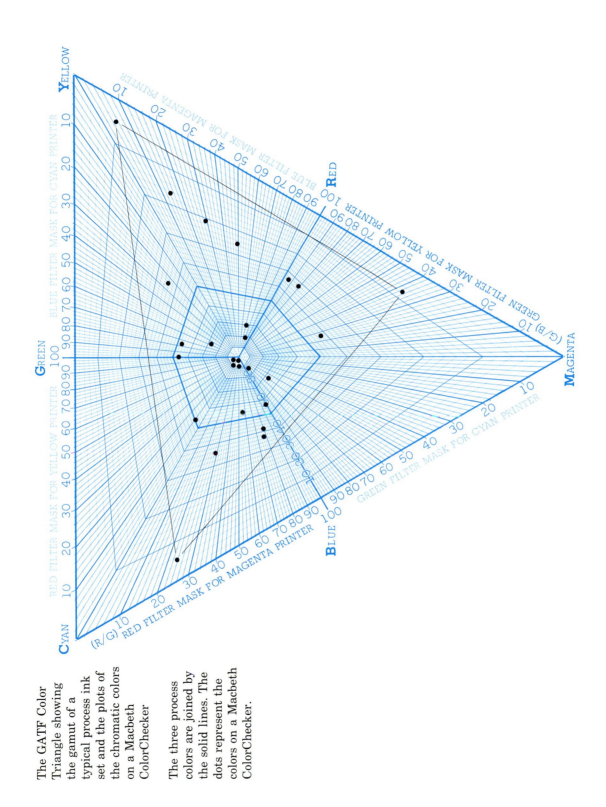

The GATF Color
Triangle showing
the gamut of a
typical process ink
set and the plots of
the chromatic colors
on a Macbeth
ColorChecker

The three process
colors are joined by
the solid lines. The
dots represent the
colors on a Macbeth
ColorChecker.

two- and three-color overlaps and the influence of the black printer. The major value of this method is to determine whether a change in one or more of the colors in an ink set will be sufficient to satisfy the hue and saturation requirements of the job.

A further use of the GATF Color Triangle is to compute percentage mask strengths for each of the six masks that are theoretically required to fully correct for the unwanted absorptions of a printed ink set. First, the actinic densities (see chapter 4) of the inks are computed. The corresponding densities are then converted to hue and gray values and plotted on the color triangle. Finally, lines are drawn through each of the three points so that the extensions of the lines intersect the outer boundary of the triangle. The points of intersection are the percentage mask values required to correct for the unwanted absorptions of the inks. This procedure has more value as an educational aid than as a production tool, because the widespread use of color scanners has virtually eliminated the need to calculate mask percentages.

Establishing Aimpoints

The aimpoints are those values on the separation films that are monitored to ensure that the films have been properly exposed in the camera or scanner phases of the manufacturing process. The scanner method of color separation and correction has made it possible to produce films that require little or no subsequent correction. Such films may also be produced using traditional photographic procedures but only with increased time and material usage.

The key values to monitor on the separation films are those that establish whether gray balance and tone reproduction are correct. For scanned separations, five widely spaced points on the original gray scale are chosen as references. These points are tracked through the Jones diagram until the required values on the separation films have been determined. Three-point control is usually adequate for camera separation.

Apart from the five points on the gray scale of the separations, little can be done to check the separation films short of actually making proofs. If a color reproduction guide has been separated alongside the original, the individual color patches can be checked to see if the separation and correction process has been successful in

correcting for the unwanted absorptions of the printed ink films. It must be remembered, however, that the color correction process is more than just correcting for unwanted ink absorptions.

In order to check the color correction qualities of the color separations, it is possible to measure the yellow, magenta, cyan, and black dot values in a given area of the picture and to then locate that dot value combination on a color chart. In order to gauge the overall impact of the color correction, however, there is no substitute for a proof.

4 Properties of Originals

The properties of originals as they influence tone and color correction pertain to how the color separation system converts original colors into halftone or continuous-tone values on the separation films. The color separation system will often distort colors because the spectral sensitivity of the color separation system is different from the spectral sensitivity of the human eye. The distortion problem is emphasized for different kinds of originals.

There are two broad classifications of originals—those viewed by transmitted light and those viewed by reflected light. The transmission originals may be further subdivided into original transparencies and duplicate transparencies. Reflection originals may be subdivided into photographic prints and artists' originals.

Photographic color materials produce their color images using a unique set of cyan, magenta, and yellow dyes. The spectral transmission or reflectance characteristics of the different dye sets can vary from one color material to another, from the same manufacturer, and from manufacturer to manufacturer. It is important, therefore, to be able to identify the particular color material before retouching or separating. This will allow appropriate adjustments of the separation system to be made in order to reproduce the color original as the eye saw it. Manufacturers of photographic color materials will supply identification information for each of their color materials. The color separator and corrector should undertake a series of inspections or tests to determine whether supplied originals might cause problems during color separation.

Testing for Fluorescence Problems

Methods of minimizing fluorescence problems are discussed in chapter 1. Originals should be inspected for their fluorescence potential by illuminating them with a "black light" in a darkened room. A "black light" is a fluorescent tube that emits a small amount of visible blue light together with a considerable amount of ultraviolet radiation. The black light inspection test will alert the color corrector to areas in the original that may become distorted in the color separation process.

Testing for Pigment or Vehicle Compatibility

The pigments and, especially, the vehicles used in artists' paints, crayons, watercolors, pastels, and other media may record differently from their visual appearance primarily because of the different light-absorbing and light-refracting

properties of the different media. This problem may be minimized by insisting that mixed media not be used on one piece of artwork.

The only way to determine the actual color distortion due to the artists' media is to reproduce representative samples through the normal color separation system. A sampling of common artists' paints, pastels, crayons, etc., should be applied in 1-in. (25-mm) squares to a variety of commonly used artists' substrates. A gray scale is mounted alongside the samples before they are color-separated via normal plant procedures.

Actinic density. The actinic density values of the test colors may now be determined. The actinic density of a given color is equal to the density value of the original gray scale that produces a density value on the separation film equal to that produced by the color. If, for example, the density of the color on the separation negative is 0.50, the actinic density of this color is 1.20 if that is the value on the original gray scale that produces a 0.50 density value on the separation negative of the gray scale.

The use of a characteristic curve to determine actinic density

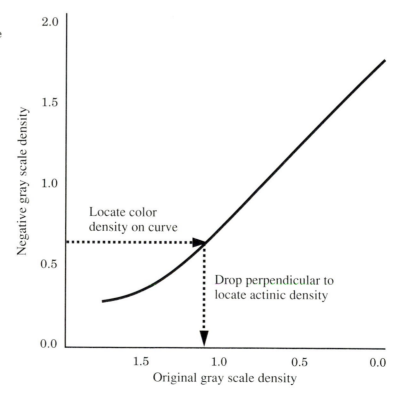

The actinic density concept also applies to direct halftone separations made on a camera or scanner. In this case, the actinic density of a given color is equal to the density value of the original gray scale that produces a dot value on the separation film equal to that produced by the color.

Test colors that look the same but that have different actinic densities will produce color correction problems if they are present in the same piece of artwork. The same problem arises when incompatible retouching dyes or pigments are used to retouch reflection or transmission color photographs.

Manufacturers of photographic materials provide color targets and suggested testing procedures for the determination of optimum color separation adjustments. These adjustments allow the separation system to reproduce the colors in each different type of original as they appear to the eye—within the color gamut limits of the reproduction system of ink and paper.

Testing Retouching Dye Compatibility

A test target has been devised by the Eastman Kodak Co. to check the compatibility of retouching dyes on E-6 Ektachrome duplicating film. The dyes in question are applied to the test transparency so that they are adjacent to their appropriate color area. The intent when applying dyes to the target is to visually match the dye to the target. Next, the target is color-separated via the normal method. If the retouching dye records the same as the target colors, the dyes are compatible. If the dyes record differently from the target, they should not be used for retouching that brand or type of film.

The approach outlined above may be duplicated for any type of film and any type of dye or pigment. Basically, the intent is to determine what visually identical dyes or pigments will record differently through a given color separation system. The tests should be repeated if there is a major change in the spectral response of the color separation system, such as a new scanner or a different type of color separation film for camera separations.

Testing Film Dye-Set Compatibility

The dye sets in different types of color film, and even those within a particular type, can differ from each other. Colors that appear to be visually the same on two different types of color transparencies may record differently through the color separation system. Ideally, the same manufacturer,

type, and emulsion number of color film should be used for a given job such as a catalog. Where different manufacturers or types of color film are mixed within the same job, it may be necessary to use different color separation procedures in order to achieve the best results.

Eastman Kodak Co., the manufacturer of the world's most extensive range of color transparency and print materials, has developed a test kit that may be used to characterize how each film will separate through a given color separation system. The first step in using the kit is to produce an "ideal" reproduction from the supplied color guide. The objective is to obtain a visual match between the guide and a proof made from the separations. When a satisfactory "visual match" between guide and proof has been achieved, the separation adjustments should be recorded and become the basic separation setup for all color originals of this type.

The Kodak Q60A color film test target mounted on a scanner drum

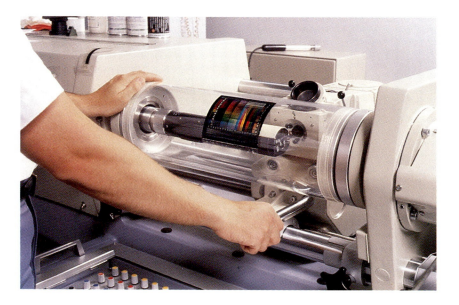

The yellow, magenta, cyan, and black tone values on the separations from the test film are measured and recorded. Next, a different color guide is mounted on the scanner (for example) and the controls adjusted until the same tone values are achieved in the test chart as were achieved on the previous test film. The scanner will now be set, from the color correction viewpoint, to produce the same "ideal" separations from a different film type. In principle, the same strategy can be applied to the nonscanner methods of

color separation, but because the color correction flexibility is less with other methods, it may not be possible to make the separations of the test charts match each other exactly.

The procedure outlined above also corrects for color distortions due to differences in color film spectral sensitivity. In other words, identical colors that record differently on different color films will record the same on the color separations. It might be thought that this correction is desirable, and indeed it usually is, especially for catalog work, but there are instances where the individual "character" of the color film should be preserved rather than masked.

Nonreproducible Colors

The analysis of originals undertaken before the separations are made should include an inspection for nonreproducible colors. The only way to determine what colors are nonreproducible is to use a color chart produced under the specified printing or proof conditions for the reproduction. The chart *must* be an accurate representation of the ultimate manufacturing conditions in order to make informed judgments. The color areas on the chart must be placed side by side with the colors in question in order to make an accurate judgment. One method of accomplishing this objective is to punch holes in the center of the chart's color sample areas, or to use a chart in the form of an ink mixing book.

Colors that cannot be reproduced by the manufacturing conditions at hand should be noted. Color transparencies, in particular, often contain colors that are more saturated than those available from the ink/substrate combination. The most difficult question for the color corrector is that of how to handle the nonreproducible color and, for that matter, the other colors in the original. The decision of degrading all color saturation equally or reproducing some accurately while distorting others will depend on the job at hand. An experienced color corrector may be able to guess the ideal tradeoffs that should be made, but more likely, a proof will have to be made in order to exercise this judgment.

Individual Color Aimpoints

Once the spectral response of the color separation system to individual color areas in any type of original has been documented, it becomes possible to determine the specific color separation aimpoints for almost any given color in

the original. In practice, this process is simplified when color scanners are used to make the separations. The scanner operator simply positions the scanning head over the color in question and notes from the digital display the relative amounts of yellow, magenta, cyan, and black that will record in that area. A color chart that is representative of actual manufacturing conditions is then used to determine the final appearance of the printed color resulting from that particular combination of colors. Scanner controls are then adjusted if a different color is desired. Such adjustments are "global" in nature, that is, they influence all areas that contain the same color and not just the color under the scanning head.

Adjustments may also be made in the photographic procedures to compensate for the different recording characteristics of the different dye sets of various films. Such adjustments, however, are not simple to make and are usually ignored in favor of making manual adjustments to the subsequent separation films.

Physical Defects and Characteristics

The duties of the person making tone and color corrections often includes the retouching of image defects or abnormalities. Such defects usually take the form of spots, scratches, and stains. Sometimes the "defect" might be unwanted image detail that needs to be airbrushed out or eliminated some other way. Physical defects are difficult to correct at the separation film stage. Not only must the retouching be skillful enough to be invisible, it must be identical on each separation. Separation film retouching should be restricted to simple defects that do not occur in important areas of the original.

The best and fastest way to handle image defect retouching is to use a color electronic imaging system. There are three major advantages with this approach:
- The zoom control of the system can be used to enlarge the defective area many times so that it is very easy to work on the area in question.
- The retouching is accomplished simultaneously on all of the separations.
- If an error is made, it is a simple matter to recall the original image and start over.

A further way of handling physical defect retouching is to make an enlarged duplicate transparency from the original and to retouch the duplicate through the use of

bleach solution and retouching dyes. Excellent results can be produced by this method, but some tonal and color distortion is inevitably introduced by the duplicating process. In most cases, this distortion may be corrected in the subsequent color separation films.

Under no circumstances should the color separator or corrector attempt to retouch the customer's original before making the separations. Not only is it very difficult to retouch images that are subsequently reproduced at a larger scale (usually the case), but errors made at this point may ruin a very expensive original. Electronic retouching or retouching on duplicate transparencies are, respectively, the first and second best choices for defect retouching, with separation film retouching coming in a distant third.

Texture

Some reflection originals will have a surface texture that may complicate the color separation and correction process. In the case of oil paintings, it is usually desirable to retain the texture of the artists' brush strokes. This effect may be retained in the separations by adjusting the camera lights so that the light illuminating the top of the painting is stronger than that illuminating the bottom. The painting should not be under glass, including copyboard glass. This setup will tend to simulate the kind of lighting found in a museum or gallery. One practical problem with this setup is that the uneven illumination will produce uneven separations. Some of this unevenness may be minimized if the camera operator partially shades the top half of the painting with a large sheet of black cardboard during exposure of the separations and masks. The board should be kept moving to avoid a sharp line on the subsequent films. Such efforts will help correct the unevenness problem, but the final adjustment will have to be made, probably through the use of chemical etching methods, by the color corrector. Pieces of white paper about 6 in. (150 mm) square should be placed at each corner of the painting in order to help judge the evenness of the separations.

A common practice when color-separating oil paintings or other reflection originals is to make a copy or conversion transparency from the original. Such transparencies are normally in the range of 4×5 in. (100×125 mm) to 8×10 in. (200×250 mm). The key advantages of this approach are that the lighting may be set for optimum results, and

the subsequent transparency may be easily mounted on a scanner drum. Unfortunately, copy transparencies usually result in some distortion of tonal and color values and a loss of image quality. In the case of an original in an art gallery, it is usually necessary to take the transparency and/or the proof to the gallery in order to note the corrections for the distortions introduced by the copying process.

The most common form of unwanted texture occurs in the form of silk-finish or pebble-finish photographic prints. These textures may show as an unwanted pattern in the final reproduction. Camera lights should be swung close to the camera in order to make the lighting as flat as possible. Care must be taken not to cause glare from the copyboard glass.

Another troublesome form of reflection copy is the previously printed reproduction. While texture is rarely a problem with this kind of original, moiré can sometimes cause concern. This type of original can be best handled on cameras by the use of the indirect separation process. The continuous-tone separation negatives should be made at reduced (50% or less) size before the screen positives are enlarged to their final size. When a scanner is used, it is sometimes possible to slightly defocus the scanning spot and to then increase the sharpness control in order to achieve satisfactory results.

5 Photographic Methods of Correction

The photographic methods of color separation and correction include those that make use of the process camera, enlarger, or contact frame. In practice, it is difficult to draw a distinction between the photographic processes of color separation and color correction as they are often parts of an interdependent system.

The use of photographic methods of separation and correction has declined since the introduction of the color scanner, particularly since the early 1970s when several models of scanners that could make screened separations to scale in one step were introduced. Nevertheless, some photographic separation and correction will still remain for the foreseeable future. Some reflective originals are too large and/or too rigid to be wrapped around the drum of a rotary scanner and consequently must be either separated on a camera or converted into the form of a color transparency. Some small printing companies that cannot justify the expense of purchasing a scanner will continue to use cameras for separations, but already, scanners are estimated to handle around 95% of color separation work.

Film Selection

The kinds of film used for color separation and correction depends on whether the direct or indirect color separation process is employed. Some desirable film qualities are independent of the process, namely high dimensional stability, long shelf life, processing machine compatibility, fine grain, exposure and development latitude, moderate speed, and responsiveness to chemical retouching.

Continuous-tone color separation film. The major difference between different types of continuous-tone color separation film is that of contrast. Films intended for making separations directly from reflection originals have medium contrast; those intended for making separations from the original through a color-correcting mask (i.e., the camera-back masking process) have a higher contrast. In those rare cases where photographic (as opposed to scanner) procedures are used for transparency color separation, medium-contrast separation film is used when the masks are made prior to the separations (i.e., the contact-frame equivalent to camera-back masking).

The other major quality of continuous-tone color separation films is color sensitivity. Ideally, the film should have high and equal sensitivity across the visible

Characteristic curves of low-, medium-, and high-contrast continuous-tone color separation films

Each curve represents the same development time.

spectrum. In practice, the spectral response of the film will depend on the camera light source. In order to make it easier to judge chemical retouching, the film should have good wet-to-dry density stability, i.e., low density dryback.

Lith color separation film. Good color sensitivity across the visible spectrum is also important for pan lith film that is used for direct-screen separation. High speed is also important as the film is exposed by light that has passed through the original, color separation filter, color correction mask, and halftone screen before it strikes the emulsion of the film.

 The other major attribute for pan lith film is good halftone dot quality. The dots should respond well to chemical etching or intensification while retaining satisfactory density.

Panchromatic masking film. Pan masking film is used to make masks prior to making color separations. Again, good color sensitivity across the visible spectrum is important, as is very high dimensional stability. Pan masking films,

A family of characteristic curves for a pan masking film

Each curve represents a different development time.

because they are normally exposed through the base, should not be coated with the antihalation backing common to other films.

Pan masking films should have low contrast. A characteristic curve with a long toe and shoulder is generally desirable for pan masking films, but to some degree the shape of the curve depends on the tone reproduction requirements of the original. A long shoulder on the masking film will help emphasize the highlight contrast of the separations.

Other masking film. The continuous-tone masking film used in the two-stage masking process should have medium contrast, high wet-to-dry density stability, low fog density, and the ability to be handled under appropriate safelights. The film should be flexible enough so that masks ranging from 1.0 gamma premasks to very light final masks can be made on the same film with changes in exposure and development. Ortho or pan lith films developed in dilute continuous-tone developer are sometimes used for making highlight masks. Low fog, neutral image color, and uniform density are some of the desirable qualities for masks made on these types of film.

Filter Selection

A wide variety of filters are available for exposing color separations or masks. The manufacturer of the films used for separation and masking will generally specify what

A family of
characteristic
curves for a blue-
sensitive masking
film

Each curve
represents a
different
development time.

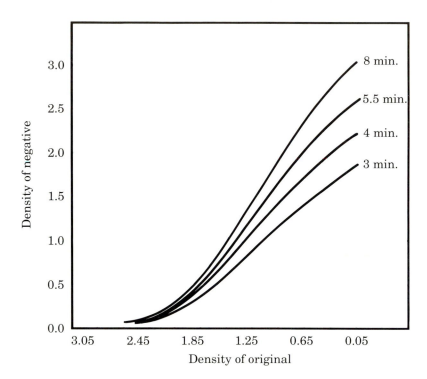

filters should be used under what lighting conditions to get
the best results for the film in question. The typical filters
used for color separation are the Wratten 25 filter for the
red-filter separation (cyan printer), the Wratten 58 filter for
the green-filter separation (magenta printer), and the
Wratten 47B filter for the blue-filter separation (yellow
printer). Occasionally, it may be desirable to deviate from
the recommendations in order to produce a better result for
a particular original.

 If wider-band filters are used for making separations
than are recommended, color separation efficiency will
decline, but there will be better detail or modeling in light
tones. If narrower-band filters are used for making
separations than are recommended, detail or modeling in
some light tones will decline, but the color separation
efficiency for strong, saturated colors will increase. For
example, if a Wratten 25 filter (medium-band) specified for
the cyan separation is replaced with a Wratten 23A filter
(wide-band), the detail in the cyan printer in skin tones
will increase, while the amount of unwanted cyan in
saturated reds will also increase. If the Wratten 25 filter is
replaced with a Wratten 29 filter (narrow-band), the detail
in the cyan printer in light skin tones will decrease and

Spectral curves for three Kodak Wratten color filters: 23A *(top),* 25 *(middle),* and 29 *(bottom)*
Courtesy Eastman Kodak Co.

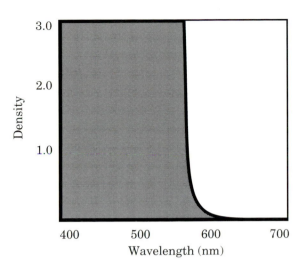

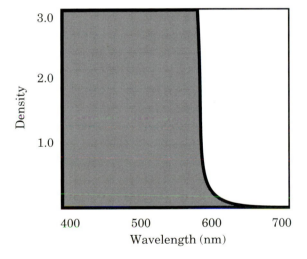

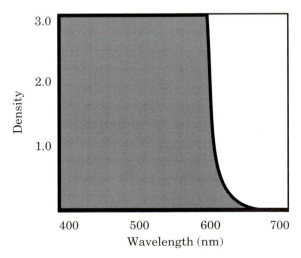

the amount of unwanted cyan in saturated reds will also decrease.

Filter selection is a function of the film, light source, and original. The film manufacturer's recommendation of filter should be followed in most cases. For some jobs, a wider- or narrower-band separation filter will improve the separation, but just because it produces an improvement for one original does not mean that it will be the best filter to use for all future jobs. When in doubt, it is best to produce a separation with the standard filter as well as one with the new filter. Two sets of proofs can be made to determine the better filter. This trial-and-error approach to filter selection should only be used on the occasional critical job and should certainly not be considered standard operating procedure.

Color Masking Overview

The color masking process uses supplementary photographic images (called "masks") to modify the densities of the separation negatives or of the original in order to improve the quality of the subsequent color reproduction. The general process of color masking can be best explained by only considering the unwanted-color absorption aspect of color correction and using the positive masking technique for illustration.

As previously explained in chapter 1, cyan inks do not transmit enough green light. An uncorrected reproduction made with a typical cyan ink would contain gray or dirty greens. It is not possible to increase the green-light transmission of cyan ink, but it is possible to reduce magenta wherever cyan prints. Magenta, of course, is the primary absorber of green light; therefore, reducing magenta wherever cyan prints has the effect of increasing the green-light reflection from that area. The increased green-light reflection due to the reduced quantity of magenta helps to compensate for the naturally poor green-light reflection of cyan inks.

When using the positive masking technique, magenta may be reduced wherever cyan prints by making a low-contrast positive from the cyan separation negative and combining the positive with the magenta separation negative. A green, for example, will record like black (i.e., nearly clear) on the cyan separation negative and nearly white (i.e., a high density) on the magenta separation negative. The positive mask made from the cyan separation

negative will have a medium density (because it is made at a relatively low contrast) in the green area and a low density in the white area. When this mask is registered with the magenta separation negative, green areas will be darkened relative to white areas; consequently, less magenta will print in greens than would be the case if unmasked separations were used.

The other major correction for unwanted color absorption concerns the blue absorption of magenta inks. Magenta inks absorb too much blue light. An uncorrected reproduction made with a typical magenta would contain gray or dirty blues. It is not possible to increase the blue-light transmission of magenta ink, but it is possible to reduce yellow wherever magenta prints. Yellow, of course, is the primary absorber of blue light; therefore, reducing yellow wherever magenta prints has the effect of increasing the blue-light reflection from that area. The increased blue-light reflection due to the reduced quantity of yellow helps to compensate for the naturally poor blue-light reflection of magenta inks.

When using the positive masking technique, yellow may be reduced wherever magenta prints by making a low-contrast positive from the magenta separation negative and combining the positive with the yellow separation negative. A blue, for example, will record like black (i.e., nearly clear) on the magenta separation negative and nearly white (i.e., a high density) on the yellow separation negative. The positive mask made from the magenta separation positive will have a medium density (because it is made at a relatively low density) in the blue area and a low density in the white area. When this mask is registered with the yellow separation negative, blue areas will be darkened relative to white areas; consequently, less yellow will print in blues than would be the case if unmasked separations were used.

Masking is also used to achieve a number of other color correction objectives, but the general procedure just detailed will accomplish the most important color correction objectives. The primary drawback with the positive masking method is that the contrast of the separations are reduced by the mask; consequently, separations must initially be made to higher-than-normal contrast.

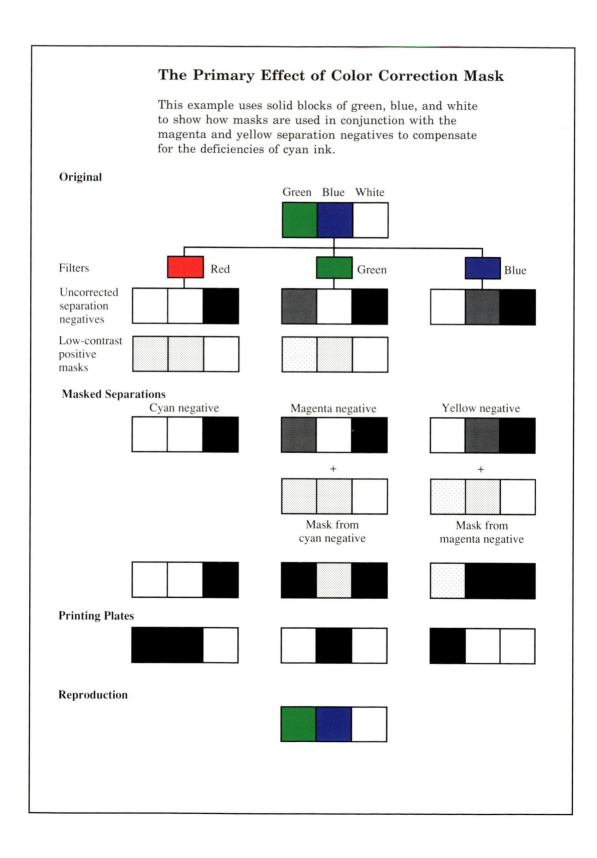

The Primary Effect of Color Correction Mask

This example uses solid blocks of green, blue, and white to show how masks are used in conjunction with the magenta and yellow separation negatives to compensate for the deficiencies of cyan ink.

Color Masking Techniques

Over the years, dozens of masking methods have been patented. Today, only a few have stood the test of time for simplicity, quality, cost, and convenience. The major methods can be classified as premasking, where the masks are made before the separations, or postmasking, where the masks are made after the separations.

In practice, the masking procedures that are documented in various instructional manuals and books should be interpreted as guidelines rather than as exact rules. Camera operators are encouraged to experiment with masking procedures in order to achieve optimal color correction. The two-stage masking procedure, in particular, offers great flexibility.

Two-Stage Method of Postmasking

The postmasking techniques have several advantages over the premasking methods:
- Camera time is reduced.
- Contrast of separations is not affected (for the two-stage technique).
- High degrees of color correction are available.
- The process is extremely flexible.

Basically, the two-stage postmasking procedure first involves making continuous-tone separation negatives, all at the same contrast range. Next contact positive masks are made at a gamma of 1.00 (100% canceling) from each of the yellow, magenta, and cyan separations. The positive masks are, in turn, registered with the appropriate separation negatives (the cyan separation negative with the magenta positive mask, the magenta separation negative with the yellow positive mask, and the magenta separation negative again with the cyan positive mask), and the final color-correcting masks are made from each combination. A diffusion sheet is placed between the masking film and the separation negative/positive mask combination before making the exposure. Finally, the color-correcting masks are combined with their appropriate separation negatives.

The key variables in the two-stage masking process are the exposure times and development times for the masking film. The following procedure should be used to establish the correct times for masking or other kinds of continuous-tone film:

1. By trial and error, establish the exposure time required to produce a 0.30 minimum density in the processed mask.

Flow diagram of the two-stage masking process

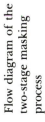

RFN = Red-filter negative
GFN = Green-filter negative
BFN = Blue-filter negative
SFN = Split-filter negative
PM = Premask
FM = Final mask

2. Using the exposure time that was just established, expose a series of four or five films. Process the films at times ranging from up to a minute above to a minute below the manufacturer's recommendations.

3. Plot a series of characteristic curves on graph paper for the films that have just been produced.

4. Place a film overlay over the graph paper and tape in position. Draw two horizontal lines on the film that correspond to the minimum and maximum densities required on the masks.

5. Place a second film overlay over the graph paper. Draw two vertical lines on the film that correspond to the points on the gray scale of the negative (or original) where it is desirable to achieve the density values selected in the previous step.

6. Finally, slide the second film overlay horizontally so that the vertical and horizontal lines on the overlays intersect with one of the characteristic curves on the base graph. The correct developing time for the mask corresponds to that of the selected characteristic curve. Interpolate if necessary. The correct exposure time will be the original time multiplied by the exposure adjustment factor (see Appendix A) corresponding to the movement along the horizontal density scale of the second film overlay.

7. Make the mask using the exposure and development times computed in the previous step. Exposure times may have to be increased slightly because of reciprocity failure effects.

Using transparent overlays to help determine the required exposure and development times

Density Aimpoints for Two-Stage Premasking

The density aimpoints for the positive masks are exactly the opposite of those for the continuous-tone separation negatives. If the separations have a 0.35 shadow density and a 1.75 highlight density, the positive mask should have a 0.35 highlight density and a 1.75 shadow density. Ideally, the mask aim densities should fall on the straight-line portion of the characteristic curve. If they do not, the aimpoints may be increased, say, to 0.45 highlight and 1.85 shadow densities, as long as the 1.40 density range is maintained. The required aimpoints on the final, or color-correcting, mask are measured on the color reproduction guide patches instead of the gray scale that was used for the positive masks. The required mask densities are those that will, when added to the negatives, make the densities of the wanted-color patches in the negatives equal to the black-patch density and make the densities of the unwanted-color patches equal to the white-patch density. For example, the yellow, red, and green ("wanted") color-patch densities in the yellow separation should equal the density of the black patch in that separation. Likewise, the blue, cyan, and magenta ("unwanted") color-patch densities in the yellow separation should equal the density of the white patch in that separation.

Achieving the correct density in one patch of the color guide is sometimes at the expense of the density in other patches. In other words, the masks are a compromise with the density being adjusted to correct the most important colors in the reproduction. Indeed, the ink color patches should be used more as a guide for general mask strength rather than an absolute objective. As stated earlier in this book, there is more to the process of color correction than just the unwanted absorptions of the process color inks.

The general guidelines for color-correcting mask densities are as follows:

Yellow final mask. The density required in the red patch should be such that when the mask is combined with the separation negative, the yellow and red patches have equal density. The density required in the blue patch is such that when the mask is combined with the separation negative the blue and white patches have equal density. The required density on the mask in the red patch is the low-density aimpoint, while that density required in the blue patch is the high-density aimpoint.

Color correction
action of two-stage
masks

The diagrams
indicate the
density profiles of
the gray scale and
color patch guides.

Gray Scale Steps

Color Patches
K W C B M R Y G

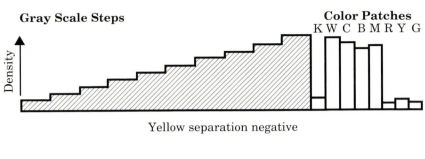

Yellow separation negative

Yellow positive made from yellow separation negative

Yellow positive and magenta separation negative

Yellow final mask made by exposing through the yellow positive and
magenta separation simultaneously

Yellow separation negative and final mask

Color-corrected yellow separation positive made by exposing through the
yellow separation negative and final mask simultaneously

Magenta final mask. The density required in the blue patch is such that when the mask is combined with the separation negative, the blue and magenta patches have equal density. The density required in the green patch is such that when the mask is combined with the separation negative, the green and white patches have equal density. The required density on the mask in the blue patch is the low-density aimpoint while that density required in the green patch is the high-density aimpoint.

Cyan final mask. The density required in the blue patch is such that when the mask is combined with the separation negative, the blue and cyan patches have equal density. The density required in the red patch is such that when the mask is combined with the separation negative, the red and white patches have equal density. The required density on the mask in the blue patch is the low-density aimpoint while that density required in the red patch is the high-density aimpoint.

Black final masks. Normal industry practice is to use the yellow and magenta final masks in combination to correct the black separation negative. This approach is satisfactory especially if a skeleton or short-range black screen positive is made from the separation negative.

Premasking by the Camera-Back Method

The premasking techniques have some advantages over the postmasking techniques:
- Fewer masks are needed than in the two-stage method, thus saving cost and time.
- This technique allows the direct-screening technique to be used.

The camera-back method is representative of the premasking techniques; contact masking transparencies and transparency masking on the enlarger easel are virtually the same as the camera-back process except that the mechanics of mask registration are different.

The camera-back process first requires that the masks be exposed on register pins in the camera back. After processing, the masks are returned to the camera back where they are placed on the same register pins over a sheet of separation film. A spacer sheet of film had been placed on the pins prior to exposure of the mask in order to

avoid subsequent misregister of the mask when it was placed on the unexposed separation film.

The separation film is exposed through the original, color separation filter, and the appropriate mask. A contact screen may be placed between the unexposed separation film and the mask if direct-screen separations are being made.

Unlike the two-stage masking method, the camera-back masking method influences tone reproduction as well as color correction. To some degree this is a limitation. If a mask is made contrasty enough to correct for the colors in question, it may flatten tonal detail by an unacceptable amount. Published recommendations for camera-back masks tend to err on the side of preserving tone reproduction at the expense of color correction fidelity.

Density Aimpoints for Camera-Back Masks

In order to preserve the tonal characteristics of the original, a fixed density range for each of the color correction masks is generally established. For reflection copy, the density range of the mask is generally 0.60 between a diffuse highlight and an original shadow density of about 1.60. The cyan mask densities should range from 0.30 to 0.90, while the masks for the magenta and yellow should range from 0.10 to 0.70. These aimpoints will place the cyan mask on the shoulder of the characteristic curve and the yellow and magenta masks on the toe. This approach will help improve gray balance and color correction in lighter tones. For direct-screen separation, the mask density range is sometimes lowered to 0.50. In the case of transparency originals, the mask range is 0.90 for contact separations or those to be made on diffuse-illumination enlargers. A mask range of 0.80 is suggested for separations being made on a condenser-illumination enlarger. The density range is measured between a diffuse highlight tone and a shadow density of about 2.40.

The "fixed density range" approach to mask making in the camera-back method does simplify tone reproduction control and separation negative production but may not necessarily produce the optimum color correction. The correction or masking percentages produced by this approach ranges from about 35% to 45%, which can result in undercorrection for ink sets with substantial unwanted absorptions.

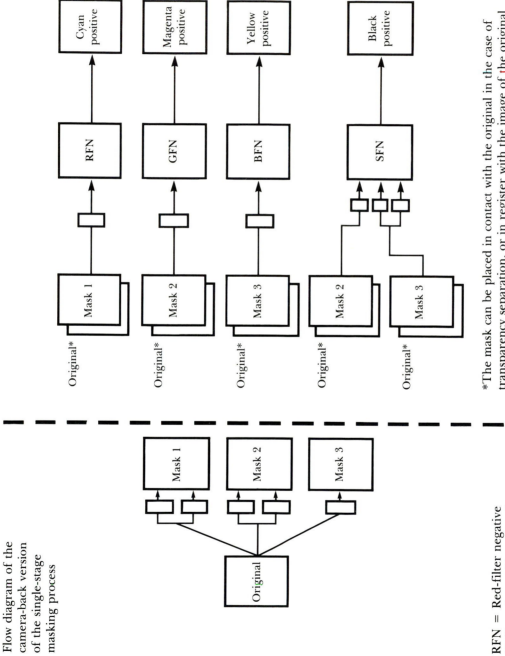

Flow diagram of the camera-back version of the single-stage masking process

RFN = Red-filter negative
GFN = Green-filter negative
BFN = Blue-filter negative
SFN = Split-filter negative

*The mask can be placed in contact with the original in the case of transparency separation, or in register with the image of the original in the case of camera-back separation.

Mask 1 is a split red- and green-filter mask, mask 2 is a split red- and blue-filter mask, and mask 3 is a green-filter mask.

Some flexibility in adjusting the color correction capabilities of the masks is available through the use of split-filter exposures when making the masks. Normally, a green filter is used to make the mask for the yellow separation, a red (or magenta) filter is used to make the mask for the magenta separation, and an orange filter is used to make the mask for the cyan separation. A combination of split-mask and split-filter techniques are used to make the black separation. The major use of split-filter mask exposures occurs when the mask for the magenta separation is made. If the cyan patch on the magenta separation exceeds the density of the white patch, then some (about 10%) blue-filter exposure should be used when exposing the red-filter mask that is used when making the magenta separation.

The influence of split-filter mask exposures on the relative actinic densities of ink color patches

This example shows the split-filter relationship of the mask for the yellow printer.

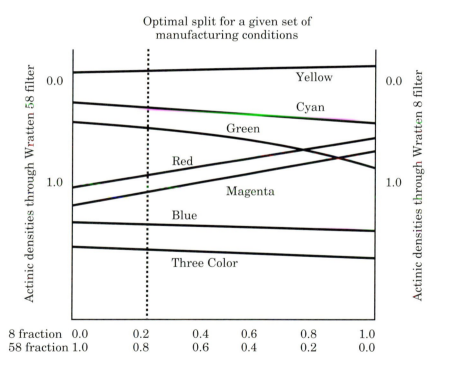

Basically, the mask densities are judged by examining the separation negative densities of the color reproduction guide. The densities of the unwanted colors in each separation are checked to see if they are the same as the density of the white patch. If the densities of the unwanted colors in a given negative are lower than the white density, the density range of the mask should ideally be

increased. If the densities of the unwanted colors in a given negative are greater than the white patch density, then the density range of the mask should ideally be reduced. Of course, mask density range adjustments will affect tone reproduction; therefore, they should be made with care. Tone reproduction is generally more important to the quality of the final reproduction than color correction.

The wanted colors in the color guide are usually ignored when using the camera-back masking approach. In general, any inaccuracies in these colors tend to be fairly minor, especially after the guide has been screened and printed. These latter operations tend to minimize any differences in density between the wanted colors.

Tone Reproduction Control

The tone reproduction requirements of the original are determined through the use of a Jones diagram and gray balance analysis of the type described in chapter 3. Three aimpoints are generally selected for monitoring the tonal qualities of photographic separations. The density values of 0.00, 0.70, and 1.60 for reflection originals, and the density values of 0.40, 1.30, and 2.40 for transparent originals are the original gray scale values that are typically monitored on the masks and separations. The exposure and development times necessary to achieve the desired aimpoints may be determined through the analysis of a set of characteristic curves similar to the approach described earlier in this chapter.

The density values cited in the previous paragraph work well for normal originals but may be varied up or down to more closely match the actual highlight, middletone, and shadow densities of poor originals. Very dark transparencies (i.e., underexposed transparencies) should use aimpoints more like 0.60, 1.60, and 2.60. As a rough guide, read the actual highlight density of the original and adjust all the aimpoints by the difference between the density of the highlight in the original and the normal 0.40 highlight target point for transparency highlights.

Tone reproduction masking. Several masking approaches may be used to adjust the tonal characteristics of the separations. One of the simplest approaches is to make additional low-density separations and register them with the normal separations. This strategy will increase the highlight-to-middletone contrast. Often, a pan lith film

developed in dilute continuous-tone developer is used to make this type of highlight mask. One drawback with this kind of mask is that they have not been color-corrected and therefore may improve highlight contrast at the expense of the color correction of light tones.

Reproductions with highlight masking *(top)* and without highlight masking *(bottom)*

If camera-back continuous-tone separations are being used, color-corrected highlight masks may be made by exposing the separations to direct-reversal type of lith contact material and developing the subsequent masks in dilute continuous-tone developer. If continuous-tone positives are being used, the same technique may be used to expand the shadow contrast of the separations. This is the only way of using masks to improve shadow contrast.

A weak positive mask placed in contact with the corresponding negative will reduce shadow contrast relative to highlight contrast. A positive made from the combination can be made to have greater highlight-to-midtone contrast than if no mask had been used.

Improving highlight contrast through the use of a shadow suppression mask

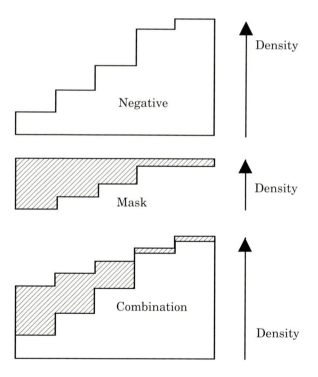

A final method of using a mask to improve highlight detail, especially specular highlights, is to first expose a short-range highlight premask by placing a sheet of pan lith film in contact with the transparency. The film is developed in dilute continuous-tone developer. After processing, the mask is registered to the transparency in preparation for exposing the normal color correction type of premask. When the color correction masks have been made, the highlight mask is discarded. The color correction

The action of
highlight masks

Note the greater
suppression of
contrast in medium
and darker tones.

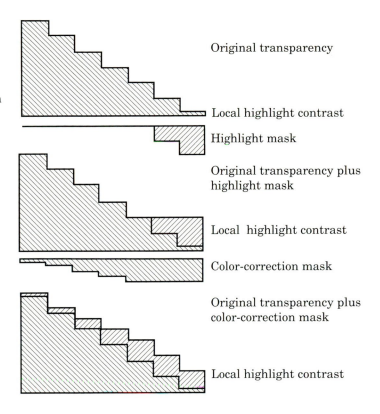

Original transparency

Local highlight contrast

Highlight mask

Original transparency plus
highlight mask

Local highlight contrast

Color-correction mask

Original transparency plus
color-correction mask

Local highlight contrast

masks are then used in the normal way to make the color
separations. The areas on the color correction mask
"protected" from exposure by the highlight mask now let
more light through and hence increase the density of the
separation negatives in those areas while leaving the other
areas unchanged. Color casts can sometimes be corrected
by exposing the highlight mask through a filter with a
complementary color to the cast. A more common method
of neutralizing color casts in transparencies is to lay sheets
of color-correcting (CC) filters over the transparencies until
the white areas appear neutral. The masks and separations
are made from the transparency and CC filter combination.

Tone reproduction at the halftone stage. Considerable
influence over tone reproduction may be exerted at the
halftone screening stage. The key factors that influence
tone reproduction are the characteristics of the screen, the
color temperature of the light source, the characteristics of
the film and developer combination, and the exposure
technique. The selection of the screen and the manipula-
tion of exposure are the major items from this list.

The highlight-to-middletone contrast range may be increased through the use of a no-screen, or bump, exposure when making screen negatives. When a bump is added, the main exposure usually has to be reduced to avoid filling in of highlight dots. The bump exposure will increase the middletone-to-shadow contrast when making screen positives. This strategy might be useful when making the black positive—high middletone-to-shadow contrast is usually desirable for this separation.

The role of the flash exposure is to extend the density range of the screen. Extension of the range means that the flash exposure helps to build the dots in the shadows of negatives or the highlights of positives. If the screen range is too short for the original, the flash will help to reduce the shadow-to-middletone contrast of positives and reduce the highlight-to-middletone contrast of negatives. Too much flash, however, will reduce the highlight contrast of positives and the shadow contrast of negatives. The term "too much" means exposure beyond the point where a satisfactory minimum size dot has been obtained on the film.

When using the direct-screen process, the flash exposure may be given through the mask. The use of this technique will tend to increase the highlight-to-middletone contrast of the reproduction at the expense of the middletone-to-shadow contrast. Consequently, the application of this technique, like all others, depends on the requirement of the reproduction.

In general, positive-working screens should be used when making screen positives from negatives, and negative-working screens should be used when making screen negatives from positives. If the screens are not used for their intended purpose, the resulting films will have an expanded middletone-to-shadow range. This may be a useful technique to employ for certain types of originals and especially for the black separation.

Undercolor Removal

The process of undercolor removal (UCR) involves reducing the amounts of yellow, magenta, and cyan ink that print in dark neutral areas of the original and subsequently achieving those neutrals through the use of the black printer. UCR is used primarily for the magazine printing industry when high-speed wet-on-wet printing sometimes causes ink transfer problems in the dark tones.

Undercolor removal is accomplished by making a positive continuous-tone mask from a masked continuous-tone black separation negative. The density of the subsequent UCR mask depends on how much UCR is desirable. The UCR mask is registered, in turn, with each of the yellow, magenta, and cyan continuous-tone separation negatives before making the screen positives. The UCR mask is not used when making the black screen positive.

UCR is achieved in the direct-screening process by placing the green and red (or magenta) filter masks in combination over the separation film and giving an additional flash exposure through the masks. The additional flash is given after the normal main, flash, and (if needed) bump exposures for that separation.

Unsharp Masking

One drawback with the photographic method of tone and color correction is that it may contribute to a loss of sharpness in the reproduction. If, for example, a sharp positive mask is combined with a sharp separation negative, the sharpness of one partially cancels the sharpness of the other. This problem may be avoided by making sure that when images of opposite polarity (negative or positive) are combined, one is unsharp. If an unsharp image is combined with a sharp image, the sharpness of the dominant image is not diminished.

Increasing image sharpness by the use of photographic unsharp masks

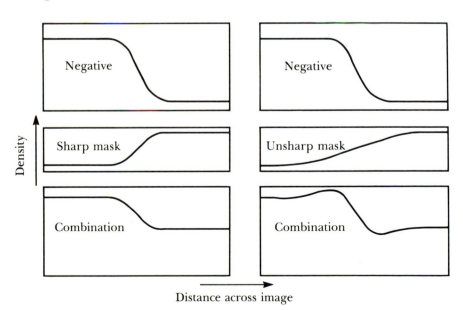

Density

Negative

Negative

Sharp mask

Unsharp mask

Combination

Combination

Distance across image

The three-color,
black, and four-
color images of a
reproduction made
without the use of
undercolor removal

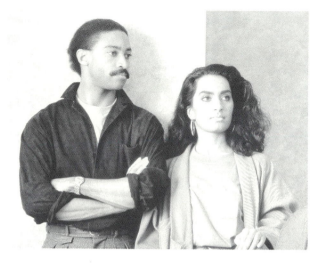

Black color
separation

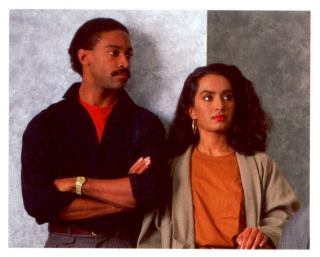

Three-color
image

Four-color image

The three-color,
black, and four-
color images of a
reproduction made
with the use of
undercolor removal

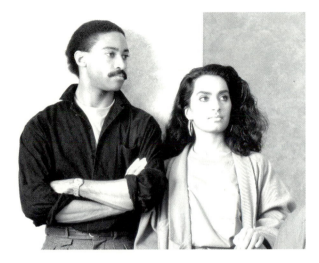

Black color
separation

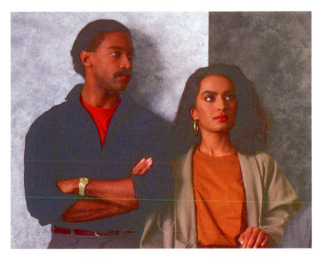

Three-color
image

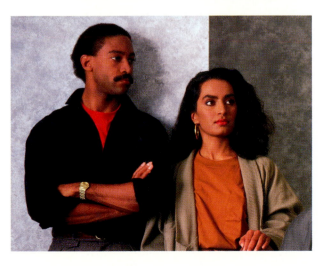

Four-color image

The masks that should be made unsharp are those used in the premask camera-back method. The films that have been designed for this process tend to give unsharp images. The mask image may be made even more unsharp when making the mask from a transparency by placing diffusion sheeting between the transparency and the unexposed masking film.

The final color-correcting mask for the two-stage masking process is also exposed through diffusion sheeting in order to reduce its sharpness. The positive masks for the two-stage method, however, should be sharp in order to avoid image fringes on the final masks.

6 Electronic Methods of Correction

Electronic color separation through the use of the color scanner is the dominant method of color separation. The scanner also introduced the electronic method of tone and color correction; indeed, the distinction between separation and correction has been virtually eliminated by incorporating both functions within the circuits of the scanner. Interestingly enough, many of the scanners of the 1950s were only color correction devices, but for this and other reasons they were not very popular.

The development of the color electronic imaging system that could electronically assemble and retouch images threatens to make all other kinds of tone and color correction obsolete. The digital imaging techniques of the systems have meant faster, more precise, limitless, and easier color, tone, and image adjustment. The only drawback to the systems at present is their high cost.

Analog Scanner Adjustment

Most of the scanners in use today have analog controls; that is, the tone and color correction adjustments are made by turning a series of knobs that actuate potentiometers. Some scanners have over fifty knobs for color adjustment and over twenty for tone adjustment. Such a degree of control usually means that a scanner can be adjusted to achieve excellent results within a shorter period of time than a camera.

Tone reproduction adjustment. The first step in the tone reproduction adjustment cycle is to set the maximum shadow and minimum highlight dots for all colors using the appropriate controls. Next the midtone, quarter-tone, and three-quarter-tone values are set. The Jones diagram and gray balance analysis described in chapter 3 are used to establish the five points on the tone scale necessary for controlling the gradation of scanner-produced separations.

The gray balance relationship is usually set when the tone reproduction is adjusted. Alternatively, all color channels may be set to the same values and a single gray balance control used to move the yellow and magenta dot values lower than those of the cyan separation.

Most scanners usually have a catchlight control that allows the operator to drop the dots from specular highlights. A further method of influencing tone reproduction is through the UCR controls. Separate

controls establish how much UCR will be applied and how far along the tone scale from dark to light.

Color correction adjustment. Many analog scanners have two sets of color correction controls. One set is used to make adjustments to compensate for the unwanted absorptions of the printing inks. The second set, called the selective controls, is used not only to fine-tune the color correction for the unwanted absorptions of the inks but also to correct for the spectral response of the scanner to the original, as well as other color correction tasks.

In order to set the primary color correction controls, a GATF Color Reproduction Guide is wrapped around the scanning drum. The "black" or "wanted"-color control knob is adjusted until the primary color in question is equal to the three-color solid. When the cyan channel is being used, for example, the "black" knob is turned until the digital display indicates that the amount of cyan in solid cyan is the same as the amount of cyan in the three-color solid. Next, the "white" or "unwanted"-color control is adjusted to make the darker of the two unwanted colors equal to white paper. Continuing with the cyan example, the "white" knob is turned until the digital display indicates that the amount of cyan printing in magenta (the darker of the two unwanted primaries, magenta and yellow) is the same as the amount of cyan in the unprinted white paper (theoretically, zero).

Finally, the color correction for the inks is completed by using the selective color controls to satisfy the "rule of three," that is, the three wanted colors in the cyan printer (green, cyan, and blue) must equal each other and equal the three-color patch in density or dot size; also, the three unwanted colors in the cyan printer (yellow, red, and magenta) must equal each other and equal the white paper in density or dot size. The wanted colors should record near 100% dot value, while the unwanted colors should record near 0% dot value.

The color corrections for the original are made by adjusting the selective color controls. The color in question is analyzed through the scanning head in order to determine the amounts of yellow, magenta, cyan, and black ink that will record in that area. By locating that particular combination of colors on a printed color chart, the scanner operator can determine how the color in the

Adjusting selective color controls on a scanner

original will appear when it is printed. If the printed color is undesirable, the correct color is noted on the chart, and the scanner is adjusted until the correct values will record in the color area in question. Of course, such an adjustment also modifies other areas in the photograph that contain the same or similar colors. The "selective" color controls are not selective when it concerns area, just when it concerns color.

The final color correction control is that for the removal of color casts. Some scanners have cast controls for both the highlight and shadow areas; adjustment entails making the signal the same through each of the color separation channels via the independent cast controls for each color. "Autobalance" control may also be used to neutralize highlight areas while undercolor addition (UCA) controls can be used to equalize the yellow, magenta, and cyan values in dark tones. A final method of cast removal involves the use of the tone reproduction controls. The tone, or gradation, controls are adjusted to include not only tone reproduction and gray balance information but also cast correction information. Thus, the same set of controls may be used to remove a color cast from the original as are used to remove a color cast (i.e., poor gray balance) from the printed sheet.

Digital Scanner Adjustment

Tone and color correction controls on most digital scanners work exactly the same as those on analog scanners. A keypad replaces the potentiometers, and a series of

commands rather than a set of knobs must be used to access the individual control functions.

The key advantage of digital scanners over analog scanners is the memory that allows the operator to instantly recall a previous setup by pressing a few keys. With the analog scanner, it is necessary to reset all of the potentiometer controls—a tedious process. The memory feature makes it possible for digital scanners to store programs, or setups, for a wide variety of printing conditions and originals.

Tone and color adjustment on digital scanners is achieved relative to one of the stored setup programs. The keypad, sometimes in conjunction with a video display, is used to add to or subtract from the tone or color settings represented by the program in use. For example, suppose the operator has selected a program for a high-key original printed on uncoated paper. If the actual printing conditions involve printing the job on newsprint with an extra 15% dot gain at the 50% level than that allowed for by the stored program, the scanner operator simply recalls the gradation function and either enters the new dot values to replace the old values or depresses the subtract key until the dot values have been reduced to the desired levels. The reduction is applied to all five tone scale control steps as needed.

The color correction controls on digital scanners are usually similar to the selective controls on analog scanners. Individual control is provided for the amount of each of the four process colors that will print in the green, yellow, red, magenta, blue, and cyan patches of a color reproduction guide. Like the analog scanner, these controls are used not only to fine-tune the correction for the unwanted absorptions of the inks and their overlaps but also for the specific color requirements of the original. The keypad is used to simply add or subtract yellow, magenta, cyan, or black to or from the green, yellow, red, magenta, blue, and cyan areas as needed. The color correction control in a digital scanner, like the analog scanner, is selective for color but not selective for area. Area or outline masks must be combined with digital images before it is possible to make local area corrections. This can only be accomplished with the addition of a video terminal or a color workstation to the scanner.

Gray Component Replacement

Gray component replacement (GCR) is a form of undercolor removal unique to scanners. It is accomplished through a computational process that has no counterpart in the photographic correction methods.

In the UCR process (shown on page 77), yellow, magenta, and cyan are removed or reduced whenever they fall in a neutral area. In other words, black is used to replace the colors in neutral areas.

In the GCR process (shown on page 84), yellow, magenta, and cyan are reduced whenever all three of those inks are present, both in neutral and colored areas. The amount of each ink removed from the color would form, when combined, a neutral gray, hence the term "gray component." The gray component is then replaced with a dot of black equal in density to the gray component that has been removed.

The major reasons for using GCR are to help minimize the influence of press color variation and to help improve ink transfer in wet-on-wet printing. The success of GCR in reducing color variation in magazine printing will ensure more frequent use of this technique in future.

In order to avoid the loss of shadow density when high levels of UCR or GCR are used, the process of undercolor addition (UCA) is employed. UCA is used to add back yellow, magenta, and cyan in dark tonal values. UCA helps to preserve shadow contrast while retaining the overall advantages of UCR and GCR. The UCA function is incorporated automatically into the GCR controls of two makes of scanner and is available in some form on all scanners.

A key factor in the successful use of GCR or UCR is the black printer. The color separation and printing operations for the black printer are considerably more critical when the full-range GCR or UCR black is used instead of the skeleton-type black used in the conventional color separation process. The tonal properties of the black separation must be adjusted to suit the dot gain, density, and even the color of the black ink.

In general, the proper use of GCR produces results that are indistinguishable from reproductions made by conventional techniques. The major color problem concerning this technique arises, however, when the film must be retouched by hand. Most experienced color etchers have spent years adjusting yellow, magenta, and cyan dot

The three-color, black, and four-color images of a reproduction made with the use of gray component replacement

Compare these images with those on pages 76–77, which show conventional separations and those made with undercolor removal.

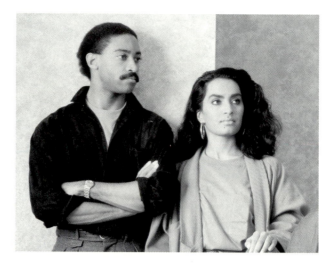

Black color separation

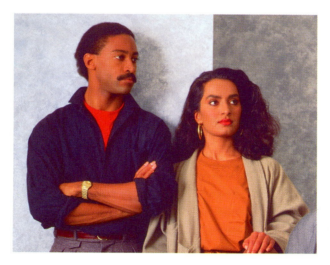

Three-color image

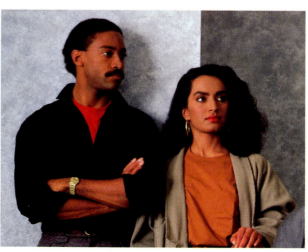

Four-color image

values to achieve correct hue and saturation and then using black to achieve the correct lightness-darkness value. The substitution of black for the gray component in each of the color areas means that GCR separations appear radically different from standard separations. Of course, color etchers can relearn the color adjustment process, but it requires time and a good four-color color chart.

Digital Image Retouching and Adjustment

The development of the electronic color imaging system meant that digitized scanned images were output on magnetic disks as an intermediate step before films were generated. Once the image is in digital form, it is easily manipulated in a precise, controlled manner. Digital images may be redefined by simply changing the values associated with a given pixel, or picture element. Today's imaging systems have the computing power and the controls to simulate—indeed, to exceed—the assembly, creation, retouching, and correction tasks performed by hand in camera, dot etching, and image assembly departments. More importantly, from the tone and color adjustment viewpoint, the systems are equipped with color video monitors so that the operator can see, almost immediately, the effect of the changes.

The color video terminal represents the greatest technological development in the history of tone and color correction. This device allows the operator to preview the effect of tone and color adjustments without the expense of making the actual separation films and subsequent proofs.

Video monitors come in two basic types. The first type is linked to the controls of a scanner and allows the operator to visually assess the tone and color adjustments before the final scan is made. A quick "prescan" is required to generate the image for display on the screen. The operator, rather than relying on printed color charts and bar graph displays of color correction settings, now assesses the whole picture at one time and makes adjustments to individual tone or color controls within that context. Any such adjustments are global in nature, that is, local area adjustment is not possible with this kind of monitor.

The second type of monitor is a part of a color electronic imaging system. These systems are used for image assembly, shape and tint generation, retouching, as well as tone and color adjustment. Time on these systems, because of their high initial cost, is very expensive.

An example of the
capabilities of a
color imaging
system

By using a color
imaging system, it
was possible to
place the white
horse from the top
scene in the
foreground of the
middle scene. The
grass has been
made more
saturated (i.e., less
magenta) than in
the actual scene.

The use of color imaging systems for tone and color correction should be restricted to local corrections. There is no reason why the required global corrections cannot be done on a scanner, especially one fitted with a color video monitor. The most conscientious global correction adjustment will not, however, produce optimal color correction. Some local correction will almost always be required.

Local corrections on a color imaging system are made by first creating an area mask that isolates the area designated for local correction. Sometimes the threshold values between the area and its surround are great enough to allow the creation of the isolation mask by electronic methods. In other cases, the image on the monitor is enlarged, and a "puck" or "mouse" is used in conjunction with a digitizing tablet to manually outline the required area. Such retouching may be done on a pixel-by-pixel basis if desired; therefore, it is very accurate. After the outlining is complete, the image is reduced to the original size. The color within the outlined area may now be redefined to literally any other color that is available on the monitor. The final image shows absolutely no evidence of retouching.

The color imaging systems are also unsurpassed in their ability to retouch image defects. Scratches, spots, and similar unwanted marks are removed by a technique

Local color correction on a color imaging system: image of yellow taxi enlarged on screen to facilitate outlining

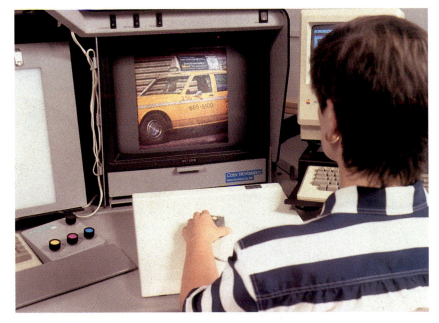

Local color
correction on a
color imaging
system: outline of
taxi filled with
mask prior to
changing the color
of the taxi

known as "cloning" or "pixel swapping," where the color
information from an adjacent area that is free of defects is
used to replace the information in the defective area. The
zoom facility of the system is utilized so that even a
relative novice with an unsteady hand is able to do a
credible retouching job on the enlarged image. An
"electronic airbrush" facility is also available on the
systems. The control is used in a manner similar to a
conventional airbrush. The color of the spray and the width
of the spray may both be preset. The intensity is controlled
by the number of passes made over the area in question.

Further retouching, which takes the form of combining
two or more images within one image, is readily
accomplished with such a system. Such adjustments are
often required in catalog work where the original
photograph may not have all of the merchandise required
in the printed catalog. Through the use of a system, the
digital image of the missing product may be dropped into
the digital image of the original photograph. Image
combinations of this type show absolutely no sign of joins
between images. It is generally impossible to tell that the
final reproduction consists of a montage of images.

While it is not possible to discern joins, the operator must
be alert to other clues that make it obvious that two
images have been combined. One giveaway is the direction

of shadows. For example, if one image has been illuminated from the left and another from the right, the direction of the shadows will be reversed within the same combined illustration. Extensive retouching would be required to alleviate this problem. Another clue as to whether images have been combined are reflections, or the lack of them, from areas adjacent to the added image. For example, if an added image that is predominantly yellow is placed alongside a strong red object, one would expect to see a slight reddish hue on the part of the yellow image adjacent to the red object.

Video Image Assessment

A key problem with using video terminals to make tone and color judgments is that the accuracy of the displays may not be high enough. Apart from potential color differences between the color monitors and the printed sheets, video displays are incapable of showing the influence of gloss, texture, sharpness, resolution, screen patterns, and graininess, all of which certainly influence the quality of the reproduction and perhaps the actual tone and color requirements.

It is possible to calibrate color video monitors so that they do not display colors that are not reproducible by the printing system; however, such displays are subject to color drifts in time. Another problem when precise color matching is required is that it is impossible to compare colors side by side when using a video monitor. Unless such a comparison is made, the accuracy of the match will suffer.

The perception of a color on the monitor will also be influenced by the ambient illumination in the room—the more intense the illumination, the less saturated the appearance of the colors on the monitor. When the monitor is being used to make color judgments, the lights in the room should be dimmed, or at the very least, the surface of the monitor should be shielded from ambient light by a series of baffles. The original transparency or reflection print should be placed in a 5,000 K viewer as close to the monitor as is practical. In some cases, it may be necessary to lower the intensity of the transparency viewer to match the generally lower intensity of video monitors. Neutral density filters may be used to reduce viewer intensity.

The role of the color monitor, from the tone and color correction viewpoint, is the same as that of the prepress

GTI's Graphiclite®
Soft-View variable-
intensity viewer
being used in
conjunction with
the Hell
CromaCom 2000
workstation
*Courtesy Graphic
Technology, Inc.,
and Hell Graphic
Systems*

overlay-type proof made from the color separations as a
check that the camera or scanner work is satisfactory. The
operator knows that the overlay proof and the image on
the monitor are not exact simulations of the final printed
sheet. They are, however, perfectly satisfactory for
assessing color balance, tone reproduction, and *relative*
color correction. An experienced operator is able to make
mental adjustments from the video display or overlay proof
to visualize the final printed appearance. Video displays
are not that far removed from the final printed appearance
that great leaps of imagination must be used to visualize
the final color. For critical color OKs, however, a "hard"
proof must be used regardless of the accuracy of the "soft"
video proof.

**Electronic
Image
Enhancement**

Several types of adjustment are possible in terms of image
qualities when using a scanner for the separation and
correction process. The electronic equivalent of the
photographic unsharp masking process is achieved by
adjusting a few simple controls on either a digital or
analog scanner.

One scanner control is provided for selecting the starting
point on the tone scale for the unsharp masking (USM)
effect. A second control is provided to determine the
magnitude of the effect. As discussed in chapter 2, the
amount of sharpening required depends on the subject

matter of the original. Changing the sharpness settings may influence the perceived contrast and saturation of the reproduction.

In the case of scanners that use a special photomultiplier for unsharp masking, the selection of the unsharp masking aperture and color filter in the scanning head will also influence the width of the USM effect at image boundaries, as well as in what separation the effect will be most pronounced. The filter color selected should generally be complementary to the color of the area receiving the increased sharpness emphasis.

Many scanners now use digital techniques for USM computation. In this case, the USM signal is derived from the main separation signal and a special USM photomultiplier. Each separation is sharpened separately through the same filter as the separation's main signal, thus avoiding potential operator error when selecting the filter color for the USM photomultiplier. Computed USM the final printed for each separation can produce more natural results with less chance of error than the optical USM used on older scanners.

Some scanners are equipped with a control that allows the operator to suppress the effects of USM in dark areas. This facility is desirable in order to neutralize the emphasis in graininess in dark tones that may result from the use of USM.

The other aspects of electronic image enhancement concern halftone dot formation, specifically dot shape and screen angle. The image quality factors influenced by dot formation include resolution and moiré. The dot shape may be selected from the several that are available for individual scanners. Screen angles are usually fixed, but some scanners do offer some choice.

The selection of dot shape, screen angle, and screen ruling is made to maximize the resolution of the reproduction and to minimize the moiré in the reproduction. The individual printing conditions determine the "best" combination of dot angle, shape, and ruling; therefore it is not possible to specify a universal standard. In some cases, the presence of an unusual pattern in a fabric or other textured object in the original may require a change in one or more of the halftone dot factors in order to minimize moiré patterns caused by the interaction of the original with the halftone screen.

7 Local Correction Strategies

The objective of the color separation process is to produce separation films that have been corrected for the various deficiencies of the color reproduction process. The color scanner method of separation, because of its many controls, is generally capable of achieving this objective. Indeed, today's camera separation methods are also capable of coming very close to this objective because of the exposure computers, automatic processors, and improved films available. Local correction techniques, therefore, should play little role in adjusting tone and color values that could (and should) be adjusted on the scanner or camera. Yesterday's process variability, which was the reason for much of the hand or manual correction, no longer exists. The decline in the number of people working as dot etchers or color retouchers at the same time as the rapid growth in the number of color separations being made is ample evidence of this transition.

Local correction techniques are used in those cases where it is impossible to achieve the desired results through scanner or photographic techniques. Local correction is also used to make the customer-directed alterations that are written on the proofs.

The process of local correction involves physically protecting the areas that are acceptable and altering the other areas until they have the desired appearance. In chapter 6, the use of digital retouching techniques to achieve local correction is described. The nondigital techniques are described in chapters 8, 9, and 10, while the general strategies related to defining the objectives of local correction are discussed in this chapter.

Assessing the Original

Of the several checkpoints concerning the original identified in chapter 4, the following are the most important: inspect the copy for fluorescence; check for nonreproducible colors; note spots, scratches, and other unwanted marks; and look for retouching that may prove to be incompatible with the rest of the colors in the original. All of these problems with the original may be reasons for the use of local correction techniques.

Another frequent reason for the use of local correction occurs when a merchandise sample is supplied for color matching one object within the photograph. This task can cause the color corrector a problem if the object in the photograph is influenced by surround colors. If, for

Simultaneous color
contrast effect
*Courtesy Leo M.
Hurvich,* Color
Vision, *1981*

The four small
colored disks are
the same on the
left- and right-hand
sides. The apparent
color differences
are caused by the
different surround
colors.

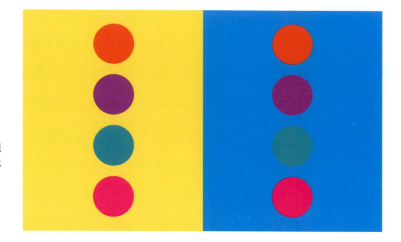

example, a yellow object is surrounded by a green
background as opposed to a red background, the
appearance of the yellow not only shifts towards the
background color but also is different from its "real" color.
The magnitude of this effect depends on the size of the
object, the size of the surround, and the color saturation of
the object and the background. Under such circumstances,
the color corrector knows not to match the color of the
supplied merchandise sample, but rather to adjust the color
of the object in the photograph so that it looks like the
merchandise sample when viewed in the context of the
overall picture. The perceived color will be that of the
object in the photograph as modified by the surround effect
of the colors around the object.

In complicated cases, the color corrector may make a
photocopy of the original and mark the tentative color
values in the critical or potentially troublesome areas
directly on the photocopy. This procedure may help to save
valuable time on color electronic imaging systems.

**Interpreting
Customer
Instructions**

Specific tone or color adjustment instructions from the
customer are sometimes supplied with the original but
more typically are marked on the proofs. Such instructions
can range from the merely cryptic to the completely
unintelligible. In most cases, the true meaning of the
instruction may be impossible to discern unless the color
corrector is physically present when the customer indicates
the color requirements or the sales representative is adept
at translating the customer's specifications into specific
instructions for the color corrector.

Using the GATF
Color Communi-
cator to indicate
desired color shifts

The easiest way to specify color is by indicating the desired color on a color chart produced under production conditions. The color corrector can then read the code for that color and ensure that the separation films are adjusted to the appropriate values.

In practice, customer instructions often come in the form of poorly defined words or phrases such as "more detail," "cleaner highlights," or "punchier reds." Sometimes the catchall phrase "match copy" will be used when it is physically impossible to achieve that objective within the constraints of the manufacturing conditions in use.

"Impossible" instructions. Instructions that indicate tone and color objectives that are impossible to achieve should not be given to the color corrector. It is the job of the sales representative to convey to the customer what is possible within the manufacturing conditions that are specified. The sales representative may suggest the use of fifth or sixth colors if it is especially important to the customer to achieve certain colors that fall outside the gamut available from the normal four-color set.

The kinds of impossible instructions that may come from the customer include the following:

- Match a color that is not reproducible within the manufacturing conditions to be used for the jobs
- More resolution (or detail), when the finest screen ruling possible for the conditions is already being used
- Sharper image, when the original is out of focus

Scanner or camera instructions. These instructions identify legitimate changes, but they are the kind of adjustment best carried out by making new separations rather than through the use of manual correction techniques. Sometimes management of prepress departments or color trade houses think that any corrections marked on the proofs can and should be done by the color corrector. In some cases it is far better, faster, and cheaper to make a new set of separations. The kinds of instructions that relate to the color separation department include the following:

- More contrast (or detail), meaning "expand the tonal differences in this area." This correction is virtually impossible to make by local retouching other than the use of opaque on shadows of positives or highlights of negatives.
- Too red (or any other color) overall, indicating poor gray balance. This may be correctable by flat-etching the film in question, but it is usually more satisfactory to remake the set to the correct balance. Flat etching will usually alter the curve shape.
- All colors are too dull (or too clean), indicating that the color correction is not enough in the "dull color" case and too much in the "clean color" case. Undercorrection can sometimes be corrected by manual techniques, but it is usually preferable to remake the set if the condition is chronic. Relative cost-effectiveness is the key issue here.

Legitimate local correction instructions. Color or tone shifts of individual areas are the domain of the color corrector. The removal of spots, scratches, or other physical defects are also usually handled by the color corrector. Such retouching instructions are usually fairly unambiguous, such as "remove spots," "fix scratch," or "make this tone even." Color instructions, however, can sometimes be rather vague or, at the other extreme, very specific.

The Munsell color tree

The hue component of color shown on an abridged color circle

The divisions are approximate.

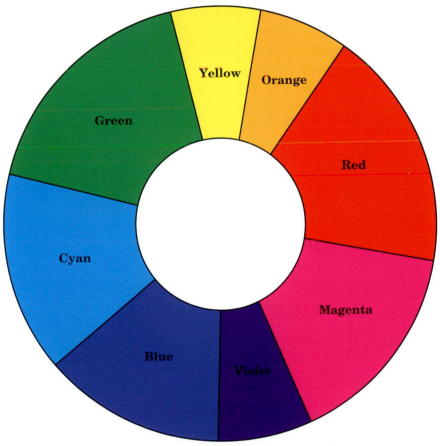

Where possible, the following framework should be used for marking *directional* color adjustments:

- **Hue.** The terms "redder," "bluer," "greener," or "yellower" should be used to indicate what direction to shift the hue of a color.
- **Saturation.** The terms "cleaner" or "dirtier" should be used to indicate what direction to shift the saturation of a color.
- **Lightness.** The terms lighter or darker should be used to indicate what direction to shift the lightness of a color.

The saturation component of color for the magenta-green hue axis

The lightness component of color for a green

Where possible, the following framework should be used for marking *magnitude* adjustments:

- **Slight.** A slight adjustment is probably equivalent to a 5–10% dot shift—enough to make a noticeable difference in appearance.
- **Moderate.** A moderate adjustment is probably about twice the shift achieved through a slight adjustment.
- **Substantial.** A substantial adjustment is certainly noticeably above a moderate shift, but it is impossible to say how far above without more information.

The terminology suggested above is capable of indicating the general desires of the customer, but it is no substitute for a color chart printed under actual production conditions where the desired color may be identified with certainty. Color charts are discussed in more detail later in this chapter.

Unclear instructions. Such comments as "I don't like it" or "do better" create somewhat of a problem for the color corrector. The comments make it obvious that the customer is not pleased, but they provide no direction as to how to improve the reproduction. In such cases, the color corrector must exercise judgment. Sometimes an inspection of previous jobs that were produced for the same customer may provide clues for color adjustments. In most cases, however, the color corrector must look at the reproduction from the customer's viewpoint and ask questions like "Does the product look good?," "Does this look natural?," "Is this appealing?," or "Would I buy this?" The answers to such questions, plus the experience of the color corrector, will often suggest the changes that are most likely to satisfy the customer.

Assessing Color Separations and Proofs

It is usually desirable to make proofs directly from the color separations before any local corrections are made. This strategy ensures that the separations have been made correctly and provides an overall impression of the reproduction that may save the color corrector the trouble of making corrections that are not necessary. The proofs will typically be produced on one of the prepress photochemical proofing materials that won't necessarily be an accurate representation of the actual printing conditions. This drawback can be overcome if a color chart produced under the actual printing conditions *and* a color

chart produced under the proofing conditions are both
available. The color corrector can track critical colors in
the proof of the job to the corresponding color in the proof
of the color chart and then to the corresponding area in the
printed color chart in order to determine the appearance of
the actual printed color in the area in question.

Separations. The separation films should initially be
inspected to make sure that they are free of mechanical
defects, that they are the correct size, that the image is
oriented correctly, and any other factors that determine the
quality of the films other than dot sizes. The smallest dots
on the film should be inspected with a magnifier used in
conjunction with a dark-field viewer in order to determine
if the dots have sufficient density. If the dot fades to
nothing when viewed against a dark field, the film may
have to be intensified or, preferably, remade.

Tone reproduction and gray balance may be checked by
measuring the sizes of the dots in the target areas of the
gray scale. The correct values are those computed from the
kind of analysis described in chapter 3. The dot values in
individual critical colors may also be measured in order to
determine, via a color chart, what color will result when
the films are eventually printed. Dot size measurements
may be made with a transmission densitometer that has
been calibrated to remove the influence of the film
thickness and the nonprintable fringe of the dot from the
measurements.

Proofs. The proof should be placed in a standard viewing
booth for evaluation. Initially, the proof should be
evaluated without reference to the original or any specific
instructions for the job. In practice, this will be easier to do
for natural scenes that contain a number of "memory"
colors (e.g., sky, grass, ocean, skin, or neutrals).
Manufactured products and abstract originals will give few
visual clues. Any unnatural color balance or tonal
separation should be noted. In such cases, the job may have
to be re-separated.

The proof is now judged with respect to the original and
to any instructions specific to that job. The intent at this
stage is to first identify those areas that satisfy the tonal
and color objectives of the reproduction; in other words, to
identify the areas that do not have to be corrected. The

remaining areas are examined to see if it is possible to modify them to make an improvement in the reproduction. For example, an increase in color saturation may be desirable but impossible in a given area.

Any planned changes in dot values can be marked with a greaseproof pencil on a film overlay that is placed over the proof. Spots, marks, and other defects can be circled to make sure that they receive attention.

It is very important that the proofs used for making color judgments are made consistently job after job. A GCA/GATF Proof Comparator target should be included on every proof in order to facilitate consistency judgments.

Color Charts and Their Use

A color chart, printed under the actual manufacturing conditions for the job, represents an indispensable tool for the color corrector. Charts should be protected from light, moisture, dirt, and other influences that could distort the colors. Ideally, charts should be replaced yearly or whenever they show signs of fading. Densitometer or colorimeter measurements should be made of key areas when the chart is new. The same areas should be rechecked with the same instrument every month to check for fading.

Several different designs of color charts are available, all of which have some advantages. The desirable attributes of a color chart include color order, equal visual difference between steps, simplicity of use, inexpensive to produce or purchase, compact size, and extensive color range. For plants using five or six colors, charts that use all the colors in question are necessary. The combinations of black with two process colors are required when GCR is incorporated in the separations.

There are three basic designs used for color charts:
• The Munsell-Foss Color Chart, which was distributed by GATF and is based on the principle of perfect color order in the printed charts
• Charts that are based on a regular grid that exhibits the overlap of declining percentages of two process colors— the grid is repeated page after page as a fixed percentage of the third color is added across all colors on each page
• The Image Scan Tint Book, where the chart takes the form of an ink mixing book with each page containing 21 colors made up of a fixed percentage of two colors and a variable percentage of the third color.

GCA/GATF Proof Comparator II©

The 8½×2¼-in. GCA/GATF Proof Comparator II© (133-line/in. screen ruling) contains a four-color process pictorial that permits quick visual comparisons between a reference comparator and the comparator on the offpress proof.

A dot gain scale and Star Target for each process color allow refined visual assessment of dot area changes in proofs. Tint patches of 3% and 97% enable the reproduction of highlight and shadow dots to be checked.

Solid and tint color patches permit the measurement of single-color and two-color overprint densities. Tint levels for single colors and overprints of 75%, 50%, and 25% permit measurement of print contrast and dot gain.

Three-color neutral gray reproduction on the proof can be checked using the gray balance bars. An undercolor removal (UCR) patch with a total dot-area coverage of 300% is included. Color register can be checked using the register marks.

GCA/GATF Proof Comparator II©

An Image Scan
Tint Book, which is
used to determine
halftone dot
percentages for
selected colors

There are two general strategies used for trying to
determine what color in the color chart will match a
particular color in the original. One approach is to use two
gray area masks that have holes in the center slightly
smaller than the squares on the color chart. One area
mask is placed over the color in the original while the
other is moved across the color chart when searching for
the closest match. The idea behind the gray area mask is
that the extraneous background in both the copy and the
color chart will be covered by the mask, hence making it
easier to compare the two colors. One problem with this
approach is that the influence of the surround color on the
appearance of the color in the original will be eliminated,
thus affecting the accuracy of the perceived match.

When comparisons are made between the original and
the proof, the use of an area mask to isolate a given color
will not adversely influence color perception because the
same surround will be around the color on both the proof
and the original. For significant differences between the
size of the original and the size of the reproduction,
different-size area masks may have to be used in order to
ensure a similar viewing field. In the case of extreme
reductions or enlargements, deliberate tonal shifts will
have to be used to produce a good reproduction (see
Chapter 2). In such cases, the use of area masks would be
of little value.

A better method for comparing an area on the color chart with a color in the original is to place the two colors adjacent to each other. Some charts have holes punched in the center of the color squares to facilitate this comparison. (This again, however, eliminates the effect of the surround.) Other charts can be folded so that the colors in question may be placed side by side. The chart will become damaged rather quickly with this approach; therefore, charts in book form with a single strip of colors on each page would seem to provide the best solution to this problem.

Color charts must always be used under standard viewing conditions, and the originals they are being compared to must also be illuminated according to the viewing standards. Prepress proofs and printed color chart comparisons may be facilitated by the use of the technique described under the "Assessing Color Separations and Proofs" section of this chapter.

Materials and Tools

The outlining by hand of areas that require correcting is called **staging.** The outlining is done with a brush that applies staging lacquer, a material impervious to the subsequent etching solution but readily removed with a solvent when etching has been completed.

Brushes. Medium-sized brushes such as no. 4 or 6 should be used for staging. These brushes are large enough to provide a reservoir of staging lacquer and produce a tip small enough for the finest detail. A separate set of brushes should also be available for the application of etching solution.

Trays. White or clear plastic trays with a smooth bottom should be used for flat etching. A range of sizes related to the normal film sizes in use should be available.

Hand rest. A wooden hand rest, about 18 in. (457 mm) long and 3 in. (76 mm) wide, should be available to steady the hand when applying staging lacquer. The feet at the ends of the rest should be padded so that they don't damage the film.

Magnifier. A 10–15× magnifier should be used for inspecting dot sizes. A 2× or 3× magnifier mounted on a bench stand should be available to facilitate the staging

A selection of magnifiers used for image inspection

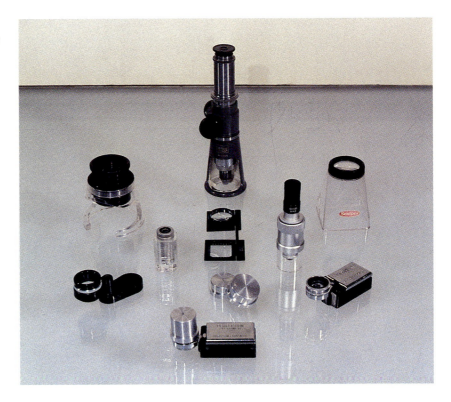

process. Linen testers should be avoided because they can damage the film through abrasion or scratching.

Densitometer. A transmission densitometer for measuring dot area and continuous-tone densities is needed. Appropriate calibration targets and data sheets should also be available.

Staging lacquers and resists. Asphalt varnishes or lacquers are available for staging. Appropriate solvents for these materials must also be supplied. These materials should allow easy removal of the staging material without damage to the film emulsion or its base.

Etching solutions. Etching solutions appropriate to the material being etched must be available. Appendix C lists the formulas of solutions for etching film.

Etching sink. A sink to accommodate two of the largest trays in use together and an inclined light box are needed. The light box should have a foot-operated sprinkler pipe at

the top edge and a drain at the bottom edge to allow frequent rinsing of the film during local etching.

Drying cabinet. A drying cabinet equipped with film hangers is required for drying staging work and films after they have been wet-etched.

Artist's stand and stool. A back-illuminated viewing stand with tiltable top and a stool that provides good back support should be available for every color corrector. A table and easel for keeping tools and copy close to the working area should also be provided.

Light table. A large light table to handle exceptionally large jobs as well as ruling, trimming, and similar tasks should be in the department.

Environment. The walls should be painted a flat neutral gray equivalent to a Munsell N8/ chip. The illumination should be 5,000 K. No windows should be in the area where critical color judgments are made. Temperature should range between 70–75 °F (21–24 °C) and relative humidity between 60–65%. Excellent ventilation should be provided, especially in areas where solvents are used. The air should be filtered to remove dust particles. Smoking should be prohibited in the color correction department.

Color viewers. A standard transparency viewer should be provided for each color corrector. A number of standard viewing booths, transparency viewers, and projection transparency viewers should be placed strategically around the department. A maintenance program should be implemented to ensure lighting consistency.

Staging Techniques

The film should be placed on the table emulsion up and oriented so that the area to be etched is away from the brush. Staging lacquer is applied to the film in short strokes with the brush being drawn towards the person applying the coating. If the brush is slightly dry it is possible to feather the line that joins the protected area from the area to be etched. This strategy will help to reduce the possibility of a distinct staging line showing on the final reproduction. The edges are painted first and then

The application of staging lacquer to a separation film

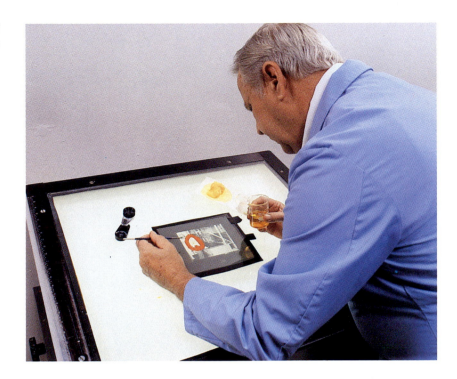

the rest of the protected area is covered with lacquer or varnish applied with a larger brush.

The staging may be built up in several steps. If the brush is too full of staging lacquer it may flow from the brush too readily and create a hard line. The staging lacquer should be dried with a low-heat fan. The appropriate solvent should be used to clean the brushes used for staging.

Caution: Excellent ventilation must be provided in the area where the solvents are used. These chemicals are dangerous if inhaled. Some (if not all) are volatile and flammable. All materials should be handled and stored according to the specific recommendations (Material Safety Data Sheets, or MSDSs) in order to minimize the risk of fire and/or explosion.

8 Chemical Retouching Methods

For most of the 100-year history of photomechanical color reproduction, chemical retouching has been the primary method of achieving the correct tonal values. Chemicals have been used to etch metal plates or cylinders, or to increase or decrease tonal values in color separation negatives or positives. Today, however, the methods of choice for local tone and color correction are electronic (chapter 6) or dry etching (chapter 10).

There are several reasons for the decline of chemical or wet etching techniques. The chemicals used for staging, staging removal, and/or etching are generally considered hazardous. Handling precautions and/or protective equipment may be required to safely use chemicals, and disposal of waste products must be done in an approved manner. A further reason for the decline in chemical retouching methods is the decline in camera dots that are most suitable for chemical etching techniques. The laser dots produced by most scanners have less etching latitude than camera dots.

A comparison of halftone dots

The "soft" dots generated through the use of a contact screen *(left)* are more suitable for chemical etching than those made by contact *(right)*

The major reasons for the decline of chemical etching techniques are the improved methods of electronic and photographic tone and color correction. It is not unusual for electronically corrected films to not require any additional correction. Photographically masked separations rarely require more than 10% dot change in any given area.

Despite the problems associated with chemical retouching, there are occasions where it is convenient to use this approach. Such occasions usually include last-minute changes where it is not practical to use the time to return to an earlier stage in the process and produce new separations.

Local Retouching Techniques

One method of local etching consists of covering the correct areas with a staging lacquer and then applying etching solution to the unstaged area (see Chapter 7). This application is usually achieved by placing the film in a tray of etching solution. The staging lacquer protects the staged areas from the etch; therefore, only unprotected areas are affected. The staging approach works best when there is a well-defined area or object that must be modified without affecting adjacent areas.

A freehand type of local retouching may be used instead of the staging approach when areas are poorly or softly defined (clouds, hair, foliage). In such cases, a harsh staging line would not be acceptable.

When the area to be etched is at the top, bottom, or one of the sides of the picture, freehand local retouching is generally fairly easy. The wet separation film is placed on an inclined wet light table with the area to be etched at the bottom. The etching solution is rapidly applied with a large brush or a cotton swab to the desired areas. Water is then used to flush the etching solution from the film. The time between the application of etch and the flushing operation depends on the strength of the etch and the amount of dot reduction desired. After flushing, the dot size is checked with a densitometer or viewed with a hand-held magnifier and the etching/flushing cycle is repeated. In order to achieve the (final) required dot size, the cycle may have to be repeated three or four times.

The other method of freehand local retouching generally involves fairly well-defined small areas that may be located within the picture area rather than along the edges. A flat light table and stronger-than-usual etching solutions are required for this technique. The etching solution is not mixed but, rather, is kept in its two separate parts.

The wet separation film is placed emulsion up on the light table. A squeegee is used to remove surface water from the film. One part of the etching solution (the hypo in the case of Farmer's reducer) is freely applied to the film and then blotted semidry with a chamois leather. Next, a brush with a fine point is used to apply the other part of the etching solution (potassium ferricyanide if Farmer's reducer is being used) to the area in question. Care must be used to keep the solution from adjacent areas. The solution should be applied in the center of the area in question and gradually worked out to the edges. Finally, a

The keeping time
of Farmer's reducer

Note: Farmer's
reducer in this
example is made
from 5 parts of
30% potassium
ferricyanide to 100
parts of sodium
thiosulfate (hypo)
solution.

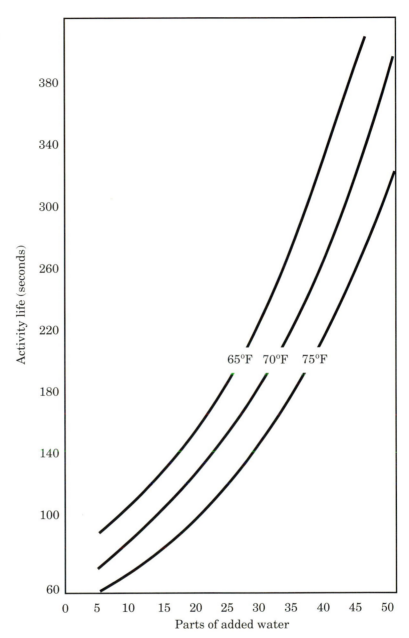

water-moistened cotton swab of water is used to flush the
etching solution from the film.

The freehand method of local etching that was just
described may be used, in some cases, as an alternative to
the staging and etching approach described earlier. The
danger with freehand etching using concentrated solutions
is that errors in judgment are more likely to occur as

compared with the slower, but more controllable, stage-and-etch approach. Freehand local etching with concentrated solutions is a technique for the experienced etcher, and only then if it is used with care.

Area Retouching Techniques

Area retouching is often called flat etching. The technique uses chemicals to reduce all the tonal values on the film. Its use is generally restricted to camera-produced color separations that have dot values higher than ideal. Placing the film in a tray of etching solution reduces all dot values, thus reducing color overall if the film is a positive or increasing color overall if the film is a negative.

A strip of clear waterproof tape is placed lengthwise over one half of the gray scale of the film to be etched. The progress of the etching can be monitored by comparing the etched half to the unetched half of the gray scale. The smallest dots on the film should be carefully monitored as they are likely to be the least dense and therefore the easiest to lose in the etching process. Ideally, the film should be placed in a transparent tray which, in turn, should be placed over a light source so that etching progress may be observed.

The percentage rate of change of dot size depends on the size of the perimeter of the dot. The etching solution attacks the fringe of all dots at an equal rate; however, since the fringe perimeter is largest at the 50% dot value, the percentage reduction in size of this tone is proportionally greater than any other on the tone scale. In practice, however, the dot shape determines whether the point of maximum reduction is at, above, or below 50%.

A sideview photomicrograph of a halftone dot, enlarged 120× *Reprinted with permission from* Kodak Bulletin for the Graphic Arts, *Issue no. 24, 1971;* ©*Eastman Kodak Company*

Film Etching

In order to facilitate the etching process, hardener should not be used in the fixing solution when the film is being processed. Before etching, the film should be soaked in a tray of water that contains a few drops of wetting agent. Care must be used when handling the wet films as they may be easily scratched.

For halftone dot etching, Farmer's reducer is the most popular. This solution is called a subtractive reducer and

The action of a subtractive reducer *(top),* a proportional reducer *(middle),* and a super-proportional reducer *(bottom)* on continuous-tone images

"O" indicates the original negatives, and "R" indicates the reduced negative. In the block diagrams, the lightly shaded areas show the relative amounts of silver removed from four typical density areas by each reducer.

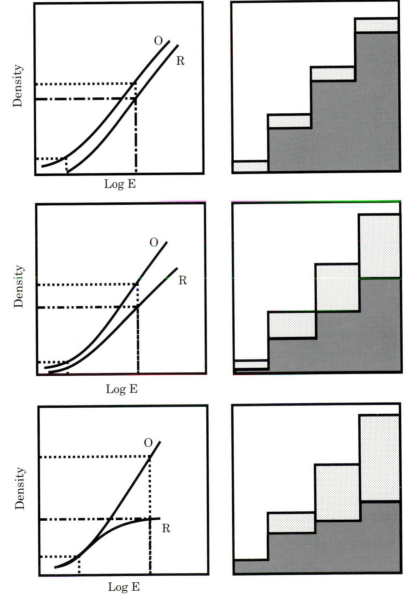

tends to remove light areas of the image at the same rate as darker parts. In the case of halftone dots, Farmer's reducer attacks the fringe of the dots, thus reducing their areas, before it starts to significantly reduce the density of the dots. Farmer's reducer may also be used to etch continuous-tone separations and masks. The contrast range of a continuous-tone image should be unchanged because the minimum and maximum densities are reduced by the same amount.

In cases where it is desirable to reduce the overall density of a continuous-tone image at a proportional rate, one of the proportional reducers should be used. Proportional reducers have a chemical action proportional to the amount of silver in a given area. Darker tones lose more density than lighter tones when this type of reducer is used, and the contrast of the image is reduced.

Film Intensification

Intensification is the opposite of reduction or etching. It is a process where weak photographic images may be darkened by the chemical action of the intensifier.

Intensification is used when camera-produced films contain dots that are too weak for the subsequent contacting process. In cases where a film has been overetched, the intensification process may also be useful in restoring part of the image. This process only works on images that are still visible—if exposure was too short to record a visible image or if the image was completely removed during etching, intensification will not restore the image. For continuous-tone images, the intensification process tends to increase the density of the darker tones at a faster rate than the lighter tones; in other words, the contrast increases. Mercuric chloride intensifier is the formula most commonly used for this purpose.

Plate and Cylinder Etching

The application of etching solutions to letterpress blocks reduces the area of the printing dots, whereas the application of etching solutions to gravure cylinders increases the volume of the printing cells. The approach taken by most companies today is to avoid re-etching plates or cylinders by making sure the films produce the desired results. It is not, however, always possible to ensure the suitability of films in advance; therefore, proofs have to be made from the plate or cylinder to determine if local corrections are required.

The use of the letterpress method for process color printing has declined to a point where it is almost extinct. By contrast, flexography, the other relief printing process, has enjoyed substantial growth. Such growth is likely to continue into the foreseeable future, especially if the presses are developed that will allow flexography to penetrate markets other than flexible packaging and newspapers.

Letterpress blocks or plates for process color are usually made of copper. The primary etchant for this metal is ferric chloride. Plates that are made of zinc may be etched with nitric acid. Flexographic plates have either been made of rubber via a duplicating process from letterpress blocks or have been produced directly from a negative via photochemical methods. In either case, dots on flexographic plates cannot be etched even though areas may be physically removed through the use of a knife or another type of cutting tool. In practice, direct correction of flexographic plates is virtually nonexistent.

A large percentage of gravure cylinders is now produced by mechanical engraving techniques. Direct engraving from halftone images, especially for the magazine industry, is also common. These developments, together with the development of appropriate off-press proofing techniques, have made it possible to achieve virtually all of the tone and color corrections before the cylinders are made. In this respect gravure now resembles lithography.

The primary use of etching solutions in the rotogravure industry is for preparing cylinders for package printing. A substantial amount of flexible packaging work and long-run carton work is printed by gravure.

Staging techniques for plates or cylinders resemble those for film. That is, an etch-resistant lacquer is applied with a brush to all areas where no etching is required. Asphaltum is normally used for this purpose. An additional step when etching metal is to protect the surface of the plate or cylinder from the etching solution. A special roll-up ink is applied with a roller to the surface of the plate or cylinder. Next, the ink is dried with a fan. The staging varnish is then applied and dried.

The etching solutions may be applied by etching machine or by hand. The etcher should use heavy rubber gloves if applying etching solutions by hand. As with film etching, it is better to use several applications of a relatively weak

etching solution than to try and achieve the desired result with one concentrated etch. If the etching process goes too far, the plate or cylinder must be remade.

Safety and Environmental Concerns

Exhaust fans should be provided in areas where staging lacquer or varnish is applied for fire safety and health reasons. This is especially true in areas where solvents are being used to remove lacquer or varnish. Etching copper with ferric chloride does not produce fumes, but in the rare case where nitric acid is still being used to etch zinc, fume extraction devices should be used.

Etching solutions may produce severe pain or damage if splashed onto the eyes or skin. Heavy rubber gloves should be used when handling etching solutions, and protective goggles must be worn to protect the eyes from splashing etchants. Many Material Safety Data Sheets (MSDSs) for these products recommend wearing protective clothing during handling.

The solutions used for treating photographic images are less hazardous than those used for etching metals; nevertheless, care should be exercised when handling all materials. Rubber gloves should be worn if there are any cuts in the skin that may come into contact with the chemicals. The hands should be thoroughly washed after they have been in contact with etching or intensification solutions. The use of potassium cyanide-based etching solutions is not recommended because of its toxicity.

Waste products from chemical etching of metal should not be discharged into the sewer system. The spent solutions should be collected in special containers for shipment to a waste disposal site or properly treated on site and then discharged into the sewer system.

In the United States, waste products from chemical etching and intensification of film may be discharged into sewer systems that are publicly owned treatment works (POTWs) with local approval. Direct discharge into septic tanks, drain fields, and underground water tables is prohibited. The waste must be collected and transported to an approved disposal site.

Local authorities should be contacted regarding regulations and bylaws pertaining to chemical waste disposal. Apart from causing unacceptable environmental damage, improper chemical waste disposal will subject a company to substantial legal penalties.

9 Mechanical Retouching Methods

Mechanical retouching methods are perhaps even more uncommon than chemical retouching methods. Mechanical techniques are those primarily concerned with the removal of spots, scratches, or other unwanted marks in the image. Mechanical retouching may be applied to continuous-tone or halftone films. It is also possible to use mechanical engraving tools to physically reduce dot sizes on letterpress blocks, but today that process is so rare that it does not warrant attention here.

The mechanical approach to tone and color correction most commonly involves using opaque to either remove colors from certain areas in negatives or to make solid certain areas in positives.

Retouching Tools

The devices that are used to physically cut the surface of the film includes needle points, scalpels, scribers, scrapers, and other cutting devices of various shapes and sizes. Retouching materials include dyes, pencils, India ink, and opaque. A selection of brushes, sandpaper, a ruling pen, and a straightedge will also be useful. An airbrush is a valuable aid if the plant does a considerable amount of retouching on continuous-tone film.

Tools used for mechanical retouching of film

Mechanical Retouching of Spots and Marks

For convenience, mechanical retouching techniques applied to spot and mark removal can be classified into halftone and continuous-tone categories. The halftone techniques are those most commonly used in the printing industry.

Halftone retouching. When closing clear spots in halftone films, it is necessary to first make indentations or holes in the surface of the film in the clear spot area and then to

Black and clear
spots on a halftone
negative *(above)*
that have been
retouched by hand
methods *(below)*

fill the indentations with an opaque substance. One approach is to make a series of small holes with a small-tip litho needle. The holes may be made in either the base or emulsion sides. Next black grease marking pencil is used to fill the indentations. Excess black wax is removed with a cotton pad.

A steel-nib pen dipped in India ink may also be used to retouch white or clear spots on films. Working on the emulsion side, the pen is pressed into the emulsion several times to form a series of same-size dots in the clear area. Excess ink may be removed with a scraper when dry.

Opaque applied with a fine brush may also be used to retouch spots, scratches, and similar marks. Excess opaque may be removed with a scraper when dry. The opaque method is not preferred over the other two methods because opaque does not always form a particularly good bond to film. In general, the grease pencil method is preferred because it will allow the retouched film to be wetted without loss of retouching.

A relatively high power magnifier should be used to help guide the retouching process. In cases where a pen or brush is used, the retoucher must work quickly so that the ink or opaque does not dry too soon.

When removing black spots from halftone films, it is always necessary to work on the emulsion side of the film. A scraper should be used to carefully remove the emulsion so that the areas left behind appear similar in tonal value to the adjacent halftone dots. Sometimes, the use of a straightedge lined up along a row of dots may be helpful when the objectionable mark is fairly large. The scraper is drawn along the clear area between dots and through the mark. Obviously, this technique is restricted to tonal areas less than 50%.

Continuous-tone retouching. Continuous-tone retouching may consist either of mechanical abrasion designed to either increase or decrease density, or the use or dyes to darken selected areas. For convenience, these techniques can be either classified as either removing or adding density.

The common mechanical method of removing density from continuous-tone film is to use a scraper. Short, light scraping strokes should be used to remove the emulsion in the designated area. The length and direction of the

strokes should be changed frequently in order to avoid sharp breaks. The scrapings are dusted from the film with a wide camel's-hair brush.

Adding density to continuous-tone films in order to cover spots and scratches is a more common procedure than mechanically removing tonal values. Retouching dyes and pencils are the most common tools and materials used to retouch clear spots on films.

Retouching dyes should be prepared in a variety of strengths so that the retoucher may use the strength most appropriate to the density of the area surrounding the spots. Several light applications of the dye allow for gradual buildup in density. The dye should be dried between applications. A range of pencils is available especially for retouching film. The harder pencils are used for small sharply defined areas. Small circular strokes are used and blended together to avoid a visible pattern. A thin protective clear lacquer can be sprayed over the emulsion to protect pencil retouching.

An airbrush may be used to create vignettes on continuous-tone films. One problem with this technique is the difficulty of vignetting each of the separations the same amount. This problem exists for other types of retouching on separation films, but the absence of clear boundaries makes it difficult to use an airbrush.

Mechanical Methods of Tone and Color Adjustment

Removal of density from continuous-tone images is generally accomplished by the use of Farmer's reducer rather than mechanical techniques. It is possible to use a scraper to reduce the density of a given area, but the practical use of such techniques are generally restricted to small areas. Mechanical techniques, where used, are normally confined to increasing the density of selected areas. Dyes or pencils may be used.

Small areas may be treated with dye applied by a brush. The retoucher uses the brush and a damp cotton swab to alternatively dye and blot the image until the correct density level has been achieved. The dyed area will dry slightly darker than its wet density.

When large areas are involved, it is better to use staging techniques and a tray of dye solution rather than to attempt the application of dye with a brush. The film should be soaked in water prior to being immersed in the dye bath.

After removal from the dye, the film is rinsed in running water for about a minute. The film is blotted with a chamois leather and fan-dried. If the dyed area is too dense, a slight reduction may be made by washing with water. A further reduction is possible by immersing the film in a weak ammonia solution. A cotton swab may be used for the local application of ammonia to small over-dyed areas.

The other method of darkening tonal values in continuous-tone films is through the application of graphite powder. The surface of the film may be roughened with fine pumice powder or, alternatively, coated with a thin layer of retouching fluid in order to provide a "tooth" to hold the graphite. A stump, which consists of a roll of soft paper shaped like a pencil, is rubbed into fine graphite powder prior to application on the surface of the film.

Opaque is used to either eliminate tones (on negatives) or render them solid (on positives). In cases where it is desirable to eliminate a tone (such as the white background of an artist's drawing), opaque should be applied to a clear overlay placed over one of the negatives. The overlay is placed, in turn, over each of the separations when exposing the subsequent positives. The strategy of using an overlay lessens the possibility of misregister

The use of opaque to achieve tone and color adjustment

between individual outlining on each separation negative. Pin register techniques should be used to simplify the registration of the overlay with the separation. Hand-cut or photographic overlays are sometimes used in place of opaqued overlay masks.

10 Dry Etching Techniques

Dry "etching" techniques involve the manipulation of dot sizes through overexposure when making contact films from screened separations. The dots are not etched in the sense that they are by chemical methods, but they are changed in size in such a way that they appear as if they have been etched. The term "selective overexposure" is more descriptive of this technique.

The major drawback with dry etching is the increased use of film. The advantages, however, tend to outweigh the disadvantages. Points in favor of dry etching compared to wet etching include the following:

- Original films remain unchanged.
- Dot changes may be precisely computed.
- Accurate area masks are produced very quickly by the use of photographic techniques.
- Hard-dot films respond well to dry dot etching techniques.
- No hazardous chemicals are required.
- Greater changes in dot size are generally possible with dry systems than wet systems.

The technique of dry etching started to gain popularity in the late 1970s when roomlight contact films and microprocessor-based exposure calculators were developed specifically for dry etching. The technology has developed to the point where substantial changes in local tone or color correction may be achieved very rapidly without the telltale staging lines sometimes visible when wet etching techniques were employed.

Films for Dry Etching

Theoretically, any high-contrast graphic arts film may be used in the dry etching process. The film of choice, however, tends to be rapid-access film rather than lith film. Rapid-access films have greater processing latitude, offer more control in the mask-making process, can be readily handled under bright safelight or roomlight conditions, and have greater exposure latitude.

It is necessary to have stocks of both negative-working and reversal-type (duplicating) films on hand for the dry etching process. The negative-working film produces an image opposite to the original image; e.g., a negative from a positive. The reversal-type film produces an image the same as the original image; e.g., a positive from a positive. In general, it is possible to obtain greater dot size changes on negative-working film than on reversal-type film.

The films must have a stable base. Generally, the 0.004-in. (0.1-mm) polyester base is satisfactory for most applications, but for large images with a fine screen ruling, 0.007-in. (0.18-mm) film may be required.

Exposure Systems

An exposure system consists of a vacuum frame, a light source, and a timer. These elements may be purchased separately, but it is becoming increasingly common, especially for dry dot etching applications, to have all of the elements in a self-contained unit.

The vacuum part of the exposure system should exhaust the air from the frame very rapidly in order to speed the exposure process. Some frames are fitted with rollers or an inflatable bladder to help force the air out from between the rubber mat and the cover glass of a vacuum frame. A register board equipped with flat register pins should be available for use in the frame.

Assuming roomlight film is used, the exposing source should be a metal-halogen lamp housed in a bright reflector. Some films may require a quartz-halogen light source. A light integrator should be used in conjunction with a timer to allow precise control of exposure. Some exposure systems require only one push of a button to start the sequence of vacuum on, exposure delay, light on, light off, and vacuum off.

Computation Systems

The elements required in a system for precise computation of exposure times includes a transmission densitometer; a microcomputer; a video terminal and, ideally, a printer unit; and an appropriate software package. These elements may exist somewhat separately from each other, but they are often sold as a complete system.

The other elements required to complete the dry etching system are a light table and a film punch. It is possible to obtain a complete dry etching system that includes all elements ranging from the light source through the computer to the light table. A final element in the system is an automatic film processor loaded with chemistry suitable for the film being used.

Principles of Dot Size Adjustment

The more exposure given when making a contact from a screened separation, the larger the dot size on the resulting film. This relationship between exposure and dot size is the basic principle behind the dry dot etching process.

The exposure/dot size relationship commences at the point where an exact dot-for-dot contact of the separation has been made. Increases in exposure from this point will increase the dot size on the subsequent contact, but decreases below the time necessary to produce an exact contact will not reduce the subsequent dot size but rather will reduce the density of the dot.

The exact effect of increasing dot size on the contact through exposure depends on whether the original separation is a negative or a positive and whether the contact film is a negative-working or reversal type. If the separation is a screen positive, exposure increases will increase the dot values on the subsequent contact negative which, in turn, will mean that a plate made from this negative will have lighter tone values than on the separation positive. If the contact from the positive is made onto reversal film, the undercutting effect of overexposure reduces the dot values on the subsequent duplicate positive relative to the original positive. In other words, regardless of the type of film used for the contact, the net effect of overexposure from a positive original is to reduce the subsequent printing dot.

If the separation is a screen negative, exposure increases will increase the dot values on the subsequent contact positives which, in turn, will mean that a plate made from this positive will have higher tone values than on the separation negative. If the contact from the negative is made onto reversal film, the undercutting effect of overexposure reduces the dot sizes on the subsequent duplicate negative relative to the original and, consequently, produces a larger dot on the plate. In other words, regardless of the type of film used for the contact, the effect of overexposure from a negative original is to increase the subsequent printing dot.

The question of whether negative or positive separations are produced depends on the requirements of the platemaking process. If both increases in dot values and reductions in dot values are required in different areas of the same separation, the job will have to pass through two contacting stages. Assuming that we start with negative separations, the first contacting stage allows us to increase certain tone values on the subsequent positive. This positive is then used for the second contacting step which allows us to decrease certain printing tone values on the

subsequent negative. If positives are required at the final step, the original separations must also be positives if both tone reduction and tone increase are required.

The possible shift in tonal values possible with the dry etching technique is around 20% (depending on the original dot value) before dots start to get ragged. That is, a 50% dot may be reduced to 30% or increased to 70%, depending on whether the original film is a negative or a positive. The actual limit will depend on the film used for contacting, the quality of the dots on the original separations, and the original value.

Films may be exposed with a 0.004-in. (0.1-mm) clear spacer between the separation and the contact film. Alternatively, the separation may be exposed through the base. Such techniques will increase the rate of dot change but not the amount. Fox example, a shift of 20% at the 70% tone level might require a 10× exposure increase for emulsion-to-emulsion contact, but only a 6× exposure increase if a spacer is placed between the original separation and the contact film.

An important consideration to bear in mind when using exposure techniques to manipulate dot values on contact films is that changes in dot size are not linear throughout the tone scale. For example, 0% and 100% "dots" will not be influenced by exposure. A 99% printing dot on a negative can only gain 1% on a subsequent contact positive. The greatest change in dot size as a result of exposure will be in the tonal values where the perimeter of the dot is largest, i.e., the tone that presents the greatest undercutting opportunity. In most cases the point of maximum change will be at the 50% value, but in practice the actual value will depend on dot shape.

The overall dot growth curve has a bowed shape with no gain at either end and maximum gain in the center or middletone region. In order to determine the exact nature of the gain characteristic, individual trials will have to be run in the plant.

Exposure Computation and Programming

In order to use the dry dot etching technique in a predictable manner, trial exposures will have to be made for both mask production and dot size alteration. The results of such tests may be kept in chart form for reference or stored in the memory of one of the computerized dry etching exposure systems.

Mask exposure trials. The purpose of the mask is to isolate areas that require alteration. The masks are made from a sandwich of appropriate screen separation negatives and positives. The screen pattern is eliminated on the mask through the use of double-sided matte drafting film. The key information required from the exposure trials is the time needed to produce a satisfactory mask from a given combination of halftone films.

The best way to determine exposure for any given mask is to use a test target that consists of yellow, magenta, and cyan positive separations of a gray scale. The three screen positives of the gray scale are taped in register. Next, a sheet of contact film (generally reversal type) is placed face up in the contact frame. The film is covered with a sheet of double-sided matte drafting film, the three screen positives of the gray scale, and another sheet of double-sided matte drafting film.

A trial exposure, about four or five times normal exposure, is given to the contact film. The procedure is repeated for a wide variety of other exposure times, and the subsequent trial masks are processed and examined.

The gray scale test target, together with the two sheets of drafting film, is measured on a transmission densitometer. The density value for each step on the gray scale is recorded. Next, the masks are examined to establish the location of the last solid step on the gray scale that recorded on the mask. For high exposures, this step will lie near the shadow area of the gray scale, and for low exposures this step will lie near the highlight end of the gray scale. The exposure time required to render the lightest solid step on a given mask is recorded alongside the subsequent transmission density of that step.

A graph relating transmission density of the screen films and the exposure time required to produce a corresponding mask may now be drawn. The color corrector may now produce an isolation mask of the required density simply by measuring the transmission density of the halftone film sandwich where it is desirable to achieve a high density on the mask. The subsequent exposure required to achieve this density may now be read off the graph.

Dot adjustment exposure trials. Trial exposures for the exposure of the contact films may be carried out on negative or reversal-type films, with or without spacers. In

practice, separate trials will have to be run for each unique set of conditions.

The trial exposures are made from a gray scale containing dot values ranging from 1% to 99%. The gray scale must have been produced on the plant's camera or scanner using the halftone dot shape and screen ruling normally used in practice. A plant that makes both camera and scanner separations uses a wide variety of screen rulings, and a number of dot shapes will have to make a considerable number of trials. The computerized dry dot etching exposure systems available from several manufacturers are almost indispensible when a large number of trials are necessary.

For a given set of conditions, the contact film and the gray scale are placed in the contact frame. A series of trial exposures are made to determine the base exposure producing a contact that most closely matches the original gray scale in tonal values. Next, a series of trial exposures are made that range up to twenty times the base exposure. The subsequent dot values for each step on the gray scale for each of the trials are measured and recorded. The values in each step are then expressed in terms of how much they deviate from the original gray scale as a function of exposure.

The data collected from the exposure trials show the color corrector what exposure is necessary to shift a given step on the tone scale by a specified amount. All the information is now available to use the dry etching process to make color adjustments on an actual job.

Making Isolation Masks

Similarly to other methods of local tone and color correction, the color corrector examines the proof of the separations and decides which tonal values need to be increased, which tonal values need to be decreased, and by how much and in what color. Masks must be made that will isolate the areas that have to be increased when making contacts from negatives and also isolate the areas that have to be decreased when making contacts from positives. Several masks of each type may be needed when extensive corrections are required.

The combination of films required to isolate the correct tonal area may be determined by simply combining films on a light table and choosing that combination that creates the greatest contrast between the correction area and the

adjacent areas. Both screen negatives and positives may be combined to produce the desired isolation effect. The Eastman Kodak Co. has produced a simple dial indicator that shows the combinations of negatives and positives necessary to isolate any one of eight groups of colors.

The Kodak Color
Isolation Guide
*Courtesy Eastman
Kodak Company*

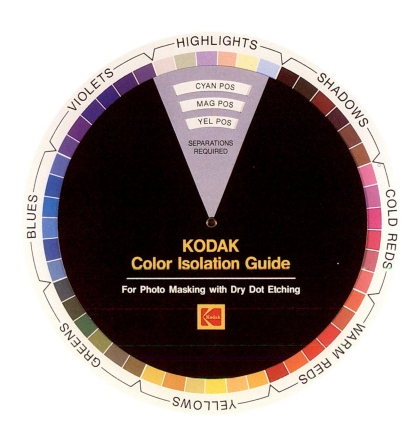

Image combina-
tions to create
isolation masks

Color to Be Isolated	Image Combinations Required
Yellows	Cyan pos., magenta pos., yellow neg.
Greens	Cyan neg., magenta pos., yellow neg.
Blues	Cyan neg., magenta pos., yellow pos.
Violets	Cyan neg., magenta neg., yellow pos.
Warm reds	Cyan pos., magenta neg., yellow neg.
Cold reds	Cyan pos., magenta neg., yellow pos.
Shadows	Cyan neg., magenta neg., yellow neg.
Highlights	Cyan pos., magenta pos., yellow pos.

Once the correct combination of halftone negatives and/or positives required to produce the isolation mask has been determined, the transmission density of the lightest tone

that must record as black on the mask is measured. Two sheets of the matte drafting film must be placed over the combination of halftone films before making the density readings. The exposure required to make a satisfactory mask is then read off the graph or table for that transmission density value.

A slight etch in Farmer's reducer may be required to remove unwanted density from the clear area of the subsequent mask. Opaque may also be applied to the dark areas of the mask to cover up spots or details. Of course, an isolation mask may be made by hand cutting a sheet of Rubylith or drawing by hand using opaque and clear film. Hand-drawn methods can be laborious to prepare and may lack the accuracy of photographic isolation masks.

The separation films and the isolation masks must be punched so that they may be combined via pin register techniques. Stable-base films and temperature-controlled environment must also be used to help minimize registration problems.

Tone and Color Control

Tone and color control is usually carried out on a local basis. Some tone adjustments, however, are made on an overall basis.

Local tone and color adjustment. The isolation masks are used in combination with the appropriate separation films to produce greater exposures in selected areas in order to increase or reduce the subsequent tonal values. If, for example, selected tone increases and decreases are required for a particular separation negative, the following procedure would be followed:

1. Place the negative in emulsion-to-emulsion contact with negative-working contact film and give an exposure sufficient to achieve a dot-for-dot positive.

Step 1: Dot-for-dot exposure through halftone separation negative

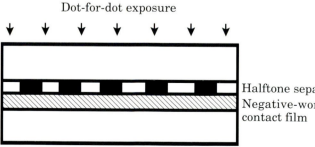

Dot-for-dot exposure

Halftone separation negative
Negative-working contact film

2. Place the isolation mask over the separation negative and contact film combination and give an exposure sufficient to increase the dot values not covered by the mask to the desired values. Sequential exposures may be given with other isolation masks at different exposure times in order to produce the desired increase in the selected tone values.

Step 2: Intentional overexposure through isolation mask and halftone separation negative

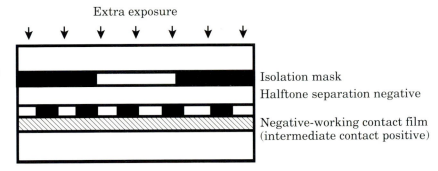

Extra exposure

Isolation mask
Halftone separation negative

Negative-working contact film
(intermediate contact positive)

3. Process the contact positive.

4. Place the intermediate contact positive in emulsion-to-emulsion contact with negative-working contact film and give an exposure sufficient to achieve a dot-for-dot negative.

Step 4: Dot-for-dot exposure through intermediate contact positive (created in steps 1 and 2)

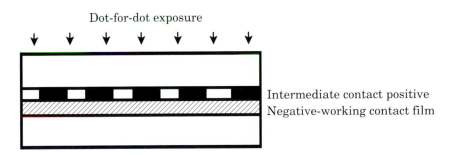

Dot-for-dot exposure

Intermediate contact positive
Negative-working contact film

5. Place the isolation mask over the intermediate positive and contact film combination and give an exposure sufficient to reduce the printing dot values not covered by the mask to the desired values. Sequential exposures may be given with other isolation masks at different exposure times in order to produce the desired decrease in the selected tone values.

6. Process the contact negative.

7. Repeat for the other separation negatives. In cases where separation positives are the starting point, the

Step 5: Intentional overexposure through isolation mask and intermediate contact positive

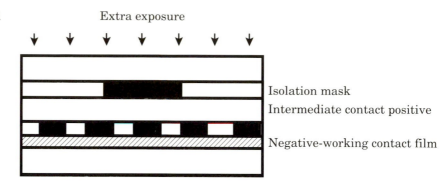

Extra exposure

Isolation mask
Intermediate contact positive
Negative-working contact film

procedure is reversed, that is, the tonal reductions are made before the tonal increases.

The correct exposure times for the sequential exposures may be determined by reference to the exposure trials that were described earlier. The exposure required to achieve a given percentage increase from a given tonal value is read off the table or graphs constructed during the trials. The base exposure is subtracted from the subsequent trial exposure in order to determine the supplementary exposure. If, for example, a 50-sec. exposure is required to achieve a 10% dot shift at the 50% level and a 20-sec. exposure is required to produce a dot-for-dot contact, the supplementary exposure will be 30 sec., which is equal to 50 sec. minus 20 sec. The first exposure will be 20 sec. to just the separation film, and the second expousre will be 30 sec. with the isolation mask covering the separation. Thus, one area in the subsequent contact would have received a total of 50 sec. exposure while the other areas would have received 20 sec.

A potential source of error when computing exposure times concerns the presence or absence of the clear part of the isolation mask. The dot-for-dot exposure is given without the mask; therefore, because the light source intensity is not reduced by the density of the clear film of the mask, the exposure effect is not strictly comparable to that produced with the mask. One method of resolving this problem is to place a sheet of clear film over the separation when determining and making the dot-for-dot exposure. Another approach to the problem is to measure the transmission density of the clear portion of the isolation mask and to increase the exposures made through the mask by an amount corresponding to the intensity loss caused by the mask.

In cases where substantial changes in dot sizes are required, the supplemental exposure may be given with a clear spacer between the separation film and the contact film. In such cases, of course, the correct exposure must be determined from the trials made with the spacer film in position.

Overall tone adjustment. The process of overall tone scale modification is used by printers to modify separation films that have insufficient allowances for press dot gain. Unless such an adjustment is made, the subsequent printing will either have heavy middletones or desaturated solids. In order to achieve saturated solids *and* normal middletones, the tonal values in the middletones of the separations must be reduced. In fact, all tonal values must be reduced, but they must be reduced more in the middletones than elsewhere. The reason for this requirement is that the percentage dot gain on press is highest in the middletone area.

No isolation masks are required to achieve the required separation film adjustment neccessary to compensate for press dot gain. To illustrate the procedure, we will assume that separation negatives have been supplied. First, emulsion-to-emulsion dot-for-dot contact positives are made from each of the separation negatives. Next, emulsion-to-emulsion overexposed contact negatives are made from each of the intermediate contact positives. The contact negatives are used to make the plates. The amount of overexposure required to produce the contact negatives will depend on the required dot gain allowance. Once this value is known, the earlier exposure trials are studied to determine the exposure time needed to achieve the appropriate dot scale shift. A Jones diagram analysis, described in chapter 3, is used to determine the dot gain allowance. Alternatively, the dot percentages in a known area, such as a gray scale, may be measured in the supplied separations and compared with other separations that are known to print well in order to determine the amount the scales are apart. The difference in tone scales represents the shift to be achieved via the dry etching approach to overall tone adjustment.

Choosing a method. There is no universal approach to tone and color correction that will be preferred in all

circumstances. One undisputed objective, however, is to achieve a high degree of global tone and color correction via photographic masking or electronic scanning techniques. This objective can be achieved quite well by today's color scanners.

Preferred local tone and color correction techniques are less clear-cut. If a job is being processed through a color imaging system, it makes sense to use digital retouching techniques to accomplish tone, color, and other adjustments. Of course, cost considerations may preclude the use of image processing systems for local retouching and correction. In such cases, wet or dry etching techniques are employed.

Dry dot etching has many advantages, especially from the precision control viewpoint, but under some circumstances film costs or other factors may rule out its use. If so, it is then that the original tone and color correction technique, stage-and-etch, is again pressed into service.

11 Evaluating Results

The results of making tone and color adjustments to the color separations may be evaluated by several techniques. The films themselves may be inspected, but the ultimate evaluation usually is based on the appearance of the proof or printed press sheet. The separations are, after all, a means to an end—the printed color reproduction.

Densitometric Evaluation

The most precise method of evaluating the tonal values of the films is through the use of a densitometer or similar kind of dot area meter. The quantification afforded by a densitometer allows the color corrector to determine the exact tonal values in a given area.

There are, however, some pitfalls associated with using a densitometer to quantify dot area. The obvious problem, the density of the film base, may be eliminated by simply zeroing the densitometer on a clear film area of the separation. A less obvious problem is the influence of the density of the soft fringe around the dots to the overall density and dot area computation.

The normal approach to eliminating the fringe density effect when making contact screen separations is to locate a nonprintable dot and to then zero the densitometer on this area. Subsequent measurements of dot values *on the same type of film* will be generally free of the influence of the fringe. A nonprintable dot is one that, while visible on the film, does not have sufficient density to record on the plate or a contact. The nonprintable dot for a given platemaking or contacting setup may be determined by exposing the contact screen halftone of the gray scale onto the plate or contact film. Normal exposure and development procedures should be followed. The subsequent image should be inspected to determine the point where visible dots on the film do not record on the plate or contact. The largest dot value that fails to record is the nonprintable dot used for zeroing the densitometer.

Laser-generated dots also have a fringe around them, but the fringe is by no means as pronounced as that obtained with certain contact screen and film combinations. The difficulty in eliminating the fringe effect from the laser dots is that such films do not have a nonprintable dot in the traditional sense of that term. The only way to deal with the fringe around a laser dot is to first make a contact from a laser-generated gray scale onto the plant's normal contact film. The contacting process virtually

eliminates the effect of the fringe, thus creating a true image of the laser-generated dots. Transmission densitometer measurements of both the original laser-generated dots and the subsequent contact film dots may now be made and recorded in the form of a correction table. Future values recorded from laser-generated dots may be converted to their true values by reference to the table.

In cases where the laser-generated films are used to expose plates directly, an electronic planimeter or microscope must be used to determine the true dot values on the plate. Subsequent corrections, of course, not only compensate for the fringe effect around the laser dot but also incorporate the effects of the dot size change due to the contacting or platemaking process itself. As this compensation must be built into the process at some stage, its inclusion here is not a disadvantage.

Density measurements of continuous-tone films are made after zeroing the densitometer according to the manufacturer's recommended procedure for density calculation. It must be remembered that continuous-tone density values will be influenced by whether the film is wet or dry. In general, wet films will have a higher density than dry films. The wet-to-dry dryback in density value will depend on the film type and the density level being measured. A plant may find it convenient to make up a wet-to-dry conversion chart for the continuous-tone film most commonly used. Simply measure and record the density values of a gray scale while still wet and then remeasure and record the same steps on the gray scale when the film is dry.

Dot area or density values in films may be used to predict the appearance of the printed color if an appropriate color chart is available. Locate the area on the chart that contains the combination of values similar to that in the separations. Interpolate if necessary. Of course, it will be difficult to judge the appearance of the entire reproduction by this technique, but the color corrector will be able to judge the appearance of critical areas with confidence.

Visual Inspection of Film

Visual inspection of tonal values in separation films is probably more common than densitometric measurement. The primary reason for this is that it is more convenient to

visually inspect etching progress rather than to keep taking the film from the etching sink to the densitometer to measure dot size.

The major problem with visual assessment of halftone values is that it is difficult to visually judge the relative size of a dot. The use of elliptical dots and laser-generated dots has made this task even more difficult. The color corrector should have available a halftone gray scale made with the screen in question. A densitometer should be used to measure the steps and the values directly recorded on the film. The scale, ideally in 5% increments, is now used as a guide or a comparator when judging the separations. Additional scales should be prepared for other screen rulings and different dot shapes. Experienced color correctors are generally more able to accurately judge dot areas than are novices.

The halftone scale for a selection of dot shapes used for lithographic printing: square dot *(top)*, chain dot *(middle)*, and elliptical dot *(bottom)* *Courtesy DS America, Inc.*

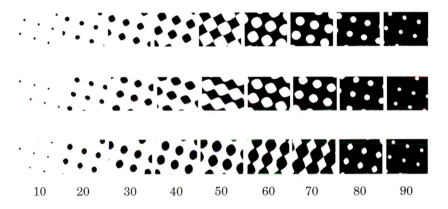

| 10 | 20 | 30 | 40 | 50 | 60 | 70 | 80 | 90 |

A 10× or 12× magnifier should be used to inspect halftone dots up to about 175-line/in. (70-line/cm) screen ruling. In some cases, a microscope equipped with a measuring reticle may be useful to determine the actual size of a given dot. Some plants may even find use for an electronic planimeter—a device that uses a microscope and a video camera to display enlarged dots on a monitor. In most cases, however, a selection of magnifiers and a handheld dot area meter will be sufficient to monitor color correction progress.

Proofing Strategy

Even the most experienced color corrector will find it difficult to judge the efficiency of the correction process without a proof. Each job contains unique combinations of colors, shapes, and sizes that make it almost impossible to

visualize the impact of all elements on the quality of the reproduction. There are generally two types of proofs used for making color judgments. The first, called an internal proof, is generally a low-cost proof that never leaves the plant. The second type of proof is called a customer or contract proof and is a simulation of the appearance of the final printed product.

Internal proofs. Internal proofs are virtually all prepress or off-press proofs. They are used by the camera and scanner operators and the color corrector to judge the efficiency of tone and color corrections. Low cost, reliability, ease of production, color consistency, and reasonable color accuracy are all attributes of a desirable internal proofing system.

 The transparent overlay type of prepress proof has proven to be popular for internal proofing. One clear advantage of such systems is that all colors do not have to be reproofed if changes are made to only one. The separation in question is simply reproofed, and the new proof is used to replace the old while leaving the other colors untouched. In the case of transfer-type (surprint) prepress proofs or press proofs, all colors must be reproofed even if only one is altered.

Using an overlay-type proof to judge color separation films

Here, an overlay proof is compared with the original color photograph.

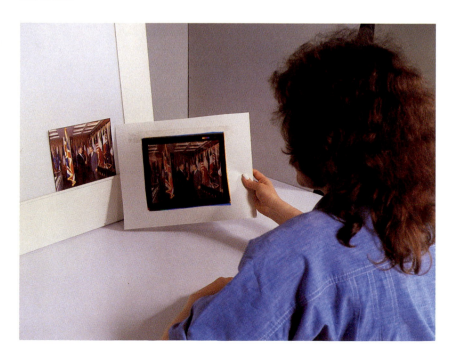

The color inaccuracies of some proofing systems are not a concern to experienced color correctors as long as such inaccuracies are consistent. A color corrector will use the internal proof to judge whether tone reproduction and color balance seem to be correct. Experience allows these individuals to mentally adjust the appearance of the proof to approximate that of the printed reproduction. The colors on the printed reproduction will differ from those on the proof, but they will tend to all shift in concert with each other; therefore, if tone and color are in balance on the proof, chances are that a similar balance will prevail on the printed product.

Exactness of color match cannot be judged directly from the internal proof. The color corrector will, however, use "before" and "after" proofs to judge the magnitude of a change that has been made on the separations. The exact color of a given area may be judged by reference to a color chart that has been manufactured under the actual printing conditions to be used for the job. If a color chart is also available on the internal proofing material, a direct visual tracking may be made from the target color in the proof to the same color in the proof of the color chart to the same area in the printed color chart. The area pinpointed on the printed color chart represents the final appearance of the target area in the proof.

Another form of internal proof is that generated via digital techniques. Chapter 6 discussed the role of video monitors in accomplishing tone and color correction via scanners or color imaging systems. A major advantage of such devices is that they may be programmed to approximately represent any given set of printing conditions.

A counterpart of the color video system on scanners or systems are the video systems that allow the operator to display color images of the film separations. The separations are registered in four separate frames and photographed through a video camera. The subsequent signals are processed through a variety of circuits that cause a good simulation of the final printed image to be displayed on the color monitor. The program in the computer section of the device may be modified to simulate virtually any set of printing conditions.

In contrast to the "soft" video proofs, "hard" physical proofs may also be prepared from digital imaging systems.

Such proofs may be modified to simulate the printing conditions, even though at the present time few have been accepted as replacements for customer proofs. The digital "hard" proofs are made by either ink jet, photographic, or electrophotographic techniques, and while they may produce fairly accurate color, the early versions do not simulate the image definition and surface characteristic aspects of printed sheets. Several manufacturers have since developed direct digital proofing systems that seem capable of overcoming these drawbacks and it is expected that these systems will become the proofing methods of choice for color imaging systems. In the meantime, the early digital proofing systems will continue to serve as internal proofs.

Some plants use photographic paper proofs or surprint-type prepress proofs as internal proofs. These proofs may be adjusted to more closely simulate the final printed sheet and, therefore, are more useful for judging critical colors and presenting an all-around better simulation of the printed sheet.

Customer proofs. The major requirement of a customer proof is that it must be a close simulation of the final printed sheet. The customer proof is the prototype of the final product and, as such, must convey a reliable representation of the qualities of the product. This requirement is why some customers insist on actual press proofs for purposes of making tone and color approvals.

In some cases customer proofs must be made to match certain conditions such as SWOP (Specifications for Web Offset Publications) or SNAP (Specifications for Non-heatset Advertising Printing). These and similar standards focus on establishing a common set of proofing conditions to ensure the compatibility of advertising and editorial separations for magazine printing.

Press proofs are rarely produced on the actual press that will print the job. The press proof should, however, match the printing conditions as closely as possible. Where practical, the same inks, paper, and color sequence is used on the proof press as will be used on the printing press. A GCA/GATF Proof Comparator should be included in every proof. Such other proofing-consistency bars as the GATF/SWOP Proofing Bar or the GATF Standard Offset Color Control Bar should be used. Press conditions are

adjusted so that the appearance of the gray scale, dot gain scales, and Star Targets on the proof matches the similar images on the press sheet.

In many cases, the transfer or surprint type of off-press proof is a very satisfactory substitute for a press proof. The transfer proofs are capable of a close simulation of a wide range of printing conditions at a much lower cost than press proofs. Substrates and pigments may be selected to suit the printing process, substrate, and inks. The resulting proofs are very close matches to the printed product. The flexibility afforded by these proofing systems means that two or more proofs made by different color separation companies, utilizing the proofing materials of a given manufacturer, may appear quite different from each other.

In cases where the proof submitted to the customer for approval differs significantly in substrate and colorant properties from the ultimate printed sheet, the sales representative should have available a sample of the proof and printed sample of a previous job. The customer may use the previous job to gauge the color shifts likely when the new job is printed and thus avoid indicating unnecessary corrections.

The GATF Color Hexagon. The GATF Color Hexagon has proven particularly useful when comparing the compatibility of a given proofing system to the printing conditions. A reflection densitometer is used to measure, through red, green, and blue filters, the green, yellow, red, magenta, blue, and cyan solids of a color guide reproduced on both the proof and the printed sheet. The three density values for a given color patch are used to locate each color on the hexagon. Starting from the center of the hexagon, the largest density value is located by moving along the hexagon axis complementary to the filter color. For example, suppose the three filter measurements of a magenta patch are as follows:

Blue filter	0.60
Green filter	1.30
Red filter	0.10

Since the highest reading is 1.30 through the green filter, the axis movement is 1.30 *away* from green (i.e., toward magenta). The next movement is along the blue-yellow axis

(because the blue-filter density is the next highest). The point is located along the blue-yellow axis, 0.60 *away* from blue, toward yellow (from the 1.30 green-filter point). The final value (0.10 red-filter reading) is located along the red-cyan axis, 0.10 *away* from red, toward cyan (from the 0.60 blue-filter point). The point so located is the plot for that color. The procedure is repeated for other colors, and the points are connected so that a hexagon is formed.

The hexagons for proof and printed sheet are compared; ideally, they should be exactly the same. If one hexagon is larger than the other, they may be equalized by either increasing the ink or proof density of the inner hexagon, or decreasing the ink or proof density of the outer hexagon. If there is a hue difference between the yellow, magenta, and cyan solids of the proof and print, the pigments must be changed for the proof or printing inks. If there is a hue difference between the blue, green, and red overprints, they may be adjusted by changing individual primary color ink densities of the proof or print, adjusting the trapping characteristics of the print, by changing the color sequence, or by changing the hues of the primary pigments used for the proof or printing inks. Clearly, all color and tone properties must be considered at the same time before making a change in proofing or printing conditions. Adjustments are made with the objective of reducing overall differences to the absolute minimum.

Viewing Conditions

Color proofs and originals must be judged under standard lighting conditions in order to make reliable assessments of tone and color correction. In the United States the standard conditions are documented in ANSI PH2.30-1989; the international equivalent is ISO 3664.

Most color separation trade houses and prepress departments of large printers are well equipped with standard viewers for both transparencies and reflection prints or proofs. Some printing companies have special customer-approval rooms where the lighting and other conditions match those of the ANSI standard. It is in the customer's office, however, where the lack of standard viewing conditions become most noticeable and most critical. In order to overcome this problem, some companies have given standard viewing booths to their clients. Others supply their sales representatives with suitcase-type portable viewers. However they are achieved, it is

A portable color
viewing booth, the
SHOW-OFF®
*Courtesy GTI
Graphic
Technology, Inc.*

important that standard viewing conditions are used when
anyone in the color reproduction cycle is making critical
color judgments that have implications for the tone and
color correction process.

**Judging the
Reproduction**

The reproduction, whether it be a proof or a press sheet,
should initially be judged in isolation; that is, it should not
be compared to the original at this stage. The ultimate
customer for the printed product will not have the original
available for comparison; therefore, the customer will judge
the reproduction on its own merits.

The first quality to assess is the tone reproduction. The
key question to ask is "Is the tonal separation in the
critical areas of the reproduction satisfactory?" The critical
areas will depend on the subject. For example, if the
subject includes many light pastel tones and few dark
tones, the critical areas are highlight tones.

The next quality is color balance. The key questions are
"Are the grays neutral?" and "Do the colors seem to have
a natural hue?" The assessment of color balance relies on
the observer's internal framework of memory colors.
Memory colors are those that occur in nature such as blue
sky, green grass, human skin colors, foliage, and earth
colors. Of course, there is a great variation within each

Normal color balance ("gray balance") *(top)* compared with a reproduction that has poor color balance *(bottom),* which is particularly noticeable in the background

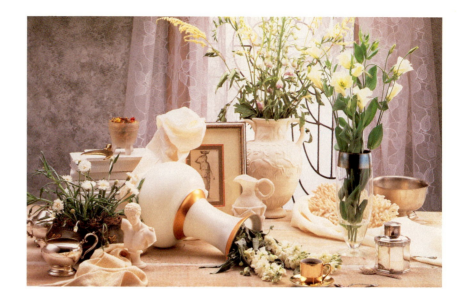

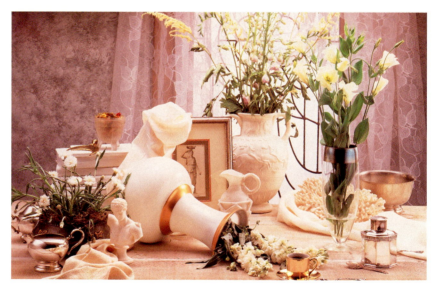

memory color classification so the observer will not insist that there is one unique color for blue sky. The observer will, however, know when a color is outside the bounds of acceptable memory colors.

Product colors or man-made colors cannot be assessed without a reference because the observer does not have a memory color framework for every manufactured product. In fact, any given product can be manufactured in virtually any color. The concept of a memory color is, therefore, virtually useless in this case.

The next step is to inspect the image quality of the reproduction: "Is the image sharp, or too sharp?," "Can I resolve the fine details?," "Is the job in register?," "Has the separation process introduced unwanted graininess?," and "Is there an objectionable moiré pattern in the reproduction?" Some of these factors such as graininess and unsharpness may be present in the original, but the objective at this stage is to judge the reproduction without diagnosing the reasons for defects.

Finally, the image is examined for spots, scratches, staging lines, and other physical abnormalities. Careful attention should be paid to areas that have been retouched during the color separation and correction process. The reproduction should be free of all such defects.

The purpose of the review to this stage is to judge the reproduction for naturalness and overall appeal. The objective is to achieve a reproduction such that a member of the print-buying public will judge it to be a good reproduction.

The next stage of the review process is in some cases more critical than the first. This stage usually involves judging the accuracy of product colors or other colors where an exact match is desirable. The original or the merchandise sample or other color reference must be examined at this stage.

The process of comparing a reflection original with a proof or reproduction is fairly straightforward; the two are simply placed side by side in a standard viewing booth. When comparing a transparency with a proof or reproduction, the proper procedures should be followed to ensure that a valid comparison is made. For example, 35-mm or 2¼×2¼-in. (57×57-mm) transparencies should be placed in one of the ANSI standard projection viewers which, in turn, should be placed inside the viewing booth. Transparencies 4×5 in. (102×127 mm) and larger should be taped in the center of an ANSI standard transparency viewer. The viewer should be placed inside the viewing booth, and the surface of the transparency viewer not covered by the transparency should be covered so that there is at least a 2-in. (51-mm) white surround around the transparency. The illuminated surround area shall not exceed four times the transparency area.

When assessing the match between critical colors the questions should be "Is the hue correct?," "Is it too light or

dark?," and "Is it saturated enough or too saturated?" Hue may be readily modified and such changes should be indicated on the proof. Isolated colors are rarely too light or too dark. If they are, the question becomes "Are all the tones too light or too dark?" Tones may be lightened, but dark tones cannot necessarily be made darker. The question here is really one of tone reproduction and whether the color separator correctly judged the interest area of the original when the tone compression was being made.

The key problem in color matching is generally related to color saturation. The color saturation of the proof will often be lower than that in the original or product sample. Saturation can always be decreased, but there is a limit as to how far it can be increased. In order to judge the saturation limit, it will be necessary to bring a color chart inside the viewing booth. The color chart must be produced under conditions representative of the printing conditions for the job at hand. The color chart exhibits the maximum saturation available from the press/paper/ink combination in use. If the saturation of a certain color of interest in the original exceeds that available on the color chart, it is impossible to match the saturation with that combination of substrate and inks. If the saturation available on the chart exceeds that of the original, it is possible to match the saturation with the proof.

In order to improve the accuracy of visual comparisons between proof and original, the two areas in question must be placed as close as possible to each other. It may be necessary to fold the proof so that particularly critical color areas may be placed adjacent to each other.

It is important to remember that the reproduction may look better if it does not match the original. Most originals are themselves reproductions and therefore do not necessarily represent reality or even a desirable fantasy. The tone and color reproduction problem, from the color corrector's viewpoint, is often complicated by customers who do not understand what is possible or who do not know what they want, and by sales representatives who are incapable of establishing a satisfactory communication link between the creative and manufacturing aspects of the color reproduction process. At this point, the problem is not a technical one but a human one. The solution is education, and it is often the case that this is yet one more skill required of the tone and color corrector.

Appendix A
Converting Halftone Density to Dot Area

The following chart can be used to convert integrated halftone density to dot area.

Note:
- The measuring aperture of the densitometer must be large enough to include several halftone dots. Larger apertures should be used for coarser screen rulings.
- Zero the densitometer on clear film before making measurements of halftone dot areas.
- Zero the densitometer on a nonprintable dot when measuring halftones produced with a contact screen.

Integrated Halftone Density	Dot Percentage
0.000	0
0.004	1
0.009	2
0.013	3
0.018	4
0.022	5
0.027	6
0.032	7
0.036	8
0.041	9
0.046	10
0.051	11
0.056	12
0.060	13
0.066	14
0.071	15
0.076	16
0.081	17
0.086	18
0.092	19
0.097	20
0.102	21
0.108	22
0.114	23
0.119	24

Integrated Halftone Density	Dot Percentage
0.125	25
0.131	26
0.137	27
0.143	28
0.149	29
0.155	30
0.161	31
0.167	32
0.174	33
0.180	34
0.187	35
0.194	36
0.201	37
0.208	38
0.215	39
0.222	40
0.229	41
0.237	42
0.244	43
0.252	44
0.260	45
0.268	46
0.276	47
0.284	48
0.292	49
0.301	50
0.310	51
0.319	52
0.328	53
0.337	54
0.347	55
0.357	56
0.367	57
0.377	58
0.387	59

Integrated Halftone Density	Dot Percentage
0.398	60
0.409	61
0.420	62
0.432	63
0.444	64
0.456	65
0.469	66
0.481	67
0.495	68
0.509	69
0.523	70
0.538	71
0.553	72
0.569	73
0.585	74
0.602	75
0.620	76
0.638	77
0.658	78
0.678	79
0.699	80
0.721	81
0.745	82
0.770	83
0.796	84
0.824	85
0.854	86
0.886	87
0.921	88
0.959	89
1.000	90
1.046	91
1.097	92
1.155	93
1.222	94
1.301	95
1.398	96
1.523	97
1.699	98
2.000	99
∞	100

Appendix B
Exposure Adjustment Factors

A new exposure time may be computed from a trial exposure by using as a correction factor the antilog of the density difference between the trial density and the desired density. For example, if a trial exposure of 12 sec. produces a density value in a given area of 0.70, and if the desired density in that area is 0.90, the new exposure is 12 sec. multiplied by 1.585, which equals 18.96 sec. for the new exposure. The exposure adjustment factor of 1.585 is the antilog of the difference between the present density of 0.70 and the desired density of 0.90, i.e., 0.20.

In cases where the desired density is less than the present density, the exposure adjustment factor is divided into the old exposure. For example, if the old exposure of 12 sec. produced a density of 0.70, and the desired density is 0.50, then the new exposure is 12 sec. divided by 1.585, which equals 7.57 sec.

Instead of dividing by the exposure factor when a lower density is required, the old exposure may be multiplied by the reciprocal of the exposure factor. The reciprocal of 1.585 is 0.631 which, when multiplied by the old exposure of 12 sec., produces the new exposure of 7.57 sec.

In practice, the exposure adjustment factors listed below will be accurate for relatively small density changes. The accuracy of these factors diminish at higher density differences because of the reciprocity failure of the film, a condition that varies from film to film. The factors should only be applied to densities on the straight-line portion of the characteristic curve.

Difference between Present Density and Desired Density	Exposure Multiplication Factor
−1.00	10.000
−0.90	7.943
−0.80	6.310
−0.70	5.012
−0.60	3.981
−0.50	3.162
−0.40	2.512
−0.30	1.995
−0.25	1.778
−0.20	1.585
−0.15	1.413
−0.10	1.259

Difference between Present Density and Desired Density	Exposure Multiplication Factor
−0.08	1.202
−0.06	1.148
−0.04	1.096
−0.02	1.047
0.00	1.000
+0.02	0.955
+0.04	0.912
+0.06	0.871
+0.08	0.832
+0.10	0.794
+0.15	0.708
+0.20	0.631
+0.25	0.562
+0.30	0.501
+0.40	0.398
+0.50	0.316
+0.60	0.251
+0.70	0.200
+0.80	0.159
+0.90	0.126
+1.00	0.100

Appendix C
Formulas for Chemical Solutions

Caution: Read the Material Safety Data Sheet (MSDS) that accompanies each chemical before using it. Follow instructions on the MSDS for proper handling and personal protection—i.e., safety goggles, gloves, and apron. Become familiar with first-aid procedures for the chemicals used. Label all containers, using Hazardous Materials Identification System (HMIS) labeling if necessary.

Subtractive Reducers

Farmer's Reducer

Farmer's reducer is a mixture of potassium ferricyanide and hypo. This mixture is relatively unstable, and the longer it stands the weaker it becomes. It can, however, be used as part of a two-step operation, first applying the hypo solution, then the ferricyanide solution, and then the hypo once more. This procedure can be continued until the required amount of reduction is obtained. When used in a one-step procedure, the two stock solutions are mixed and used immediately.

Stock Solution A	Metric Units	U.S.* Units
Potassium ferricyanide	300 g	10 oz.
Water to make	5 L	1 gal.

Stock Solution B		
Sodium thiosulfate (hypo)	1.25 kg	2 lb.
Water to make	5 L	1 gal.

Mix only the quantity required, just before use. For staging mix:

Stock Solution A	1 part
Stock Solution B	4 parts
Water to make	32 parts

Mix Stock Solution A with water. Then add Stock Solution B and stir thoroughly. Decrease proportion of water to speed up etching; increase water to slow action.
For local reduction with brush, mix:

Stock Solution A	1 part
Stock Solution B	4 parts
Water to make	12 parts

*Note: A U.S. gallon is 128 oz.; an Imperial gallon is 160 oz.

Since the mixed solution exhausts itself quickly, only small quantities should be mixed at a time. If work is extensive, use diluted Stock Solution B first. Then apply diluted Stock Solution A. Stop action with water.

Ceric Sulfate Reducer

Ceric sulfate is the only practical dot-etching agent that keeps indefinitely. The extent of exhaustion of the solution can be readily determined by the color. Any sediment formed does no harm. Either anhydrous ceric sulfate or ceric bisulfate may be used to prepare a stock solution. A 2% sulfuric acid solution must be used for diluting it to working strength or to stop the action of the reducer.

Ceric Sulfate Stock Solution (from ceric bisulfate)

	Metric Units	U.S. Units
Ceric bisulfate	67 g	2-3/8 oz.
Sulfuric acid (sp. gr. 1.84)	20 mL	5/8 fl. oz.
Water to make	1 L	1 qt.

Ceric Sulfate Stock Solution (from anhydrous ceric sulfate)

	Metric Units	U.S. Units
Ceric sulfate, anhydrous	67 g	2-3/8 oz.
Sulfuric acid, conc. (sp. gr. 1.84)	28 mL	1 fl. oz.
Water to make	1 L	1 qt.

Sulfuric Acid Stock Solution (2% by volume)

	Metric Units	U.S. Units
Water	1 L	1 qt.
Sulfuric acid (sp. gr. 1.84)	20 cc.	5/8 fl. oz.

Caution: Add the acid slowly to the water, stirring continuously. Never add the water to the acid as this may produce violent spattering.

To use as a tray etching solution, mix 1 part of the ceric sulfate stock solution with 3 parts of the sulfuric acid stock solution. To use as a local etching solution, mix 1 part of the ceric sulfate stock solution with 1 part of the sulfuric acid stock solution.

To stop reduction, wash the film with water or, preferably, a 2% sulfuric acid solution. Allowance must be made for a certain amount of continuing action.

Proportional Reducers

A reducer of this type is normally used to reduce continuous-tone negatives or positives. Its action is such that it removes the silver in proportion to the amount present. In other words, the greater the density, the greater the reduction. Its widest use is in correcting negatives that have been properly exposed but overdeveloped. A typical formula follows:

Persulfate-Permanganate Reducer

Stock Solution A	Metric Units	U.S. Units
Water	1 L	1 qt.
Potassium permanganate	0.3 g	4 grains
Sulfuric acid (10% solution)	16 mL	1/2 fl. oz.

Stock Solution B		
Water	3 L	3 qt.
Ammonium persulfate	90 g	3 oz.

Working Solution	
Solution A	1 part
Solution B	3 parts

After reduction, clear negatives in a 1% solution of sodium bisulfite and wash thoroughly.

Sulfuric Acid Solution (10% by volume)

	Metric Units	U.S. Units
Water	1 L	1 qt.
Sulfuric acid (sp. gr. 1.84)	92.5 mL	3-1/8 fl. oz.

Caution: Add the acid slowly to the water, stirring continuously. Never add the water to the acid as this may produce violent spattering.

Super-Proportional Reducer

This reducer, as with all proportional-type reducers used on continuous-tone negatives or positives, acts in a different manner than a subtractive reducer. It attacks the darkest portions of the image first; i.e., the highlight area of a negative. The reducer has the effect of flattening the tonal scale. It is used on overdeveloped negatives of contrasty subjects. A typical formula follows:

Persulfate Stock Solution	Metric Units	U.S. Units
Water	1 L	1 qt.
Ammonium persulfate	60 g	2 oz.
Sulfuric acid, C.P.	3 mL	3/4 fl. oz.

To use the persulfate reducer, dilute 1 part of the stock solution with 2 parts of water. After reduction, immerse the film in acid fixing bath for a few moments before washing.

Persulfate Reducer, R-15	Metric Units	U.S. Units
Stock Solution A		
Water	1 L	1 qt.
Potassium persulfate	30 g	1 fl. oz.
Stock Solution B		
Water	250 mL	8 fl. oz.
Sulfuric acid (dilute solution)	15 mL	1/2 fl. oz.
Water to make	500 mL	16 fl. oz.

To use, mix 2 parts of Stock Solution A with 1 part of Stock Solution B.

Intensifiers

Mercuric Chloride

Intensification is the increase of negative density (contrast) by means of a two-step process: (1) bleaching and (2) blackening of the image. Bleaching oxidizes the metallic silver. The negative is first thoroughly washed and then immersed in the bleaching solution until the silver image becomes creamy white through to the back.

Mercuric Chloride Bleaching Solution

	Metric Units	U.S. Units
Potassium bromide	22.5 g	3/4 oz.
Mercuric chloride	22.5 g	3/4 oz.
Water to make	1 L	1 qt.

Washing for 10 min. in a stream of water completes the bleaching operation. **Caution:** Mercuric chloride is a poison and should be handled carefully. Blackening the image consists of converting the complex silver salts of the bleached image into a dark, insoluble metallic image. After being bleached by use of the mercurical formula, the negative can be blackened with any of the following:

- A 10% sulfite solution
- A developing solution such as Kodak D-72 diluted 1 to 2
- Dilute ammonia (1 part 28% concentrated ammonia to 9 parts water)

These give progressively greater density in the order listed. After redevelopment, the negative is washed and dried. The process can be repeated if necessary.

When using the chromium intensifier for continuous-tone and halftone negatives, dilute 1 part of the stock solution with 10 parts of water. After bleaching in this solution, wash thoroughly and redevelop for about 10 min. in a developer, such as D-72, that does not contain a high concentration of sulfite. After redeveloping, rinse, fix, and wash thoroughly.

Kodak In-5 Intensifier

Kodak In-5	Metric Units	U.S. Units
Stock Solution A		
Silver nitrate, crystals	60 g	2 oz.
Distilled water to make	1 L	1 qt.
Stock Solution B		
Sodium sulfite, desiccated	60 g	2 oz.
Water to make	1 L	1 qt.
Stock Solution C		
Sodium thiosulfate (hypo)	105 g	3-1/2 oz.
Water to make	1 L	1 qt.
Stock Solution D		
Sodium sulfite, desiccated	15 g	1/2 oz.
Elon (or Metol)	25 g	5/8 oz.
Water to make	3 L	3 qt.

Stock separately. For use, slowly add 1 part of Stock Solution B to 1 part of Stock Solution A. Stir to mix thoroughly. Continue stirring and add 1 part of Stock Solution C to dissolve the precipitate that was formed. Allow the solution to clear. Then add 3 parts of Stock Solution D, stirring continuously. Use the intensifier immediately after mixing.

Hardener

This formula for the after-treatment of films and plates is recommended for the treatment of negatives or positives that normally would be softened by chemical treatments

such as for stain removal, intensification, or reduction. This hardener can be used for either continuous-tone or halftone emulsions.

Special Hardener Formula	Metric Units	U.S. Units
Water	500 mL	1 pt.
Formalin*	10 mL	2-1/2 drams
Sodium carbonate, monohydrated	6 g	90 grains
Water to make	1 L	1 qt.

After hardening in the above solution for 3 min., negatives should be rinsed and immersed for 5 min. in a fresh acid fixing bath and then washed thoroughly before they are given any further chemical treatments.

*Formalin is a 40% solution of formaldehyde. This is approximately a 37% solution by weight.

Bibliography

Further information on the subject of tone and color correction may be found in other GATF books, notably:
- *Color and Its Reproduction* by Gary G. Field, 1988
- *Color Scanning and Imaging Systems* by Gary G. Field, 1990
- *Graphic Arts Photography: Color* by Fred Wentzel, Ray Blair, and Tom Destree, 1987

The particular chapters of these books, as they apply to the subjects covered by this text, are listed below together with other useful references.

Reasons for Tone and Color Correction

Basic Color for the Graphic Arts by Eastman Kodak Company, Publication Q-7, Rochester, N.Y., 1977

Color and Its Reproduction, chapters 1 and 4

Color Scanning and Imaging Systems, chapter 4

Graphic Arts Photography: Color, chapter 3

Principles of Color Reproduction by J. A. C. Yule, Wiley, New York, 1967, chapters 1–3, 5–8

The Reproduction of Colour by R. W. G. Hunt, Fountain Press, England, Fourth Edition, 1987, chapters 4–6, 9

Color Reproduction Objectives

Color and Its Reproduction, chapter 7

Color Scanning and Imaging Systems, chapter 4

Proceedings of the ISCC Conference on the Optimum Reproduction of Color, Milton Pearson, ed., Rochester, N.Y., 1971

The Reproduction of Colour, chapter 11

Characterizing the Printing System

Graphic Arts Photography: Color, chapter 5

Color and Its Reproduction, chapter 8

Properties of Originals	*Color and Its Reproduction,* chapter 9
	Graphic Arts Photography: Color, chapter 6
Photographic Methods of Correction	*Camera-Back Silver Masking with Three-Aim-Point Control* by Eastman Kodak Company, Publication Q-7B, Rochester, N.Y., 1973
	Color Separation Techniques by Miles Southworth, Graphic Arts Publishing, Livonia, N.Y., 1989, chapters 2–5
	Graphic Arts Photography: Color, chapter 7
	Principles of Color Reproduction, chapter 4
	The Reproduction of Colour, chapter 28
	Silver Masking of Transparencies with Three-Aim-Point Control by Eastman Kodak Company, Publication Q-7A, Rochester, N.Y., 1980
Electronic Methods of Correction	*Color Scanning and Imaging Systems,* chapters 5–7
	Electronic Color Separation by R. K. Molla, R. K. Printing and Publishing Co., Montgomery, W.Va., 1988, chapters 8–11
	The Reproduction of Colour, chapter 29
Local Correction Strategies, Chemical Retouching Methods, and Mechanical Retouching Methods	*Graphic Arts Photography: Color,* chapter 9
	The Lithographers Manual, Raymond N. Blair (ed.), GATF, Pittsburgh, Pa., Seventh Edition (1983) and earlier editions, chapter 8
	Photographic Retouching by Vilia Reed, Eastman Kodak Co., Rochester, N.Y., 1987
	Tone and Color Correcting by Bernard R. Halpern, GATF, Pittsburgh, Pa., 1956, chapters 6–7, 9–10, 13–14 (now out of print)

Uncloaking the Mystique of Dot-Etching by James D. Radebaugh, Kodak Bulletin for the Graphic Arts No. 24, Rochester, N.Y., 1971, pp. 3–11

Dry Etching Techniques

Effects of Dry Etching Techniques on Changing Halftone Dot Sizes by Anthony Stanton, *TAGA Proceedings,* 1983, Rochester, N.Y., pp. 440–457

"Dry Dot Etching Systems" by Debora Toth, *Graphic Arts Monthly,* October 1986, pp. 144, 146, 148, also "Dry Dot Etching" sidebar by Richard Hall on pages 146, 148

Evaluating Results

Color and Its Reproduction, chapters 11, 12

Principles of Color Proofing by Michael H. Bruno, GAMA Communications, Salem, N.H., 1986, chapter 10

Index

About the Author

Gary G. Field is professor of graphic communication at the California Polytechnic State University. He teaches courses in color reproduction, quality control, and related technical and management areas.

Mr. Field entered the printing industry in 1960 as an apprentice lithographic camera operator. He gained experience in this and related areas at color separation trade houses and printing and packaging companies in Australia and England. Mr. Field led the GATF color and photo research division for six years. His major research efforts focused on color printing, densitometry, color charts, color separation, and the systems approach to color reproduction. He presented or led workshops in advanced color separation and color printing, and he co-presented seminars in quality control and color scanning.

Gary Field received his trade education in color separation and related areas at the Melbourne College of Printing and Graphic Arts, Australia, and a theoretical foundation in printing technology from the Nottingham Polytechnic in England. He also holds an MBA degree from the University of Pittsburgh. Mr. Field gained the Insignia Award in Technology from the City and Guilds of London Institute for his research work into color correction.

Author of the GATF books *Color and Its Reproduction* and *Color Scanning and Imaging Systems,* Mr. Field has also written over 30 technical or research papers. He is an active member of a number of professional societies, including Fellow of both the Institute of Printing and the Royal Photographic Society, and member of the Technical Association of the Graphic Arts, and the Inter-Society Color Council.